George W.

1790 GRA OUR

of Long Island

2019

Carol and Steve,

Happy 50th

wedding anniversary!

JGrasso

George Washington's
1790 GRAND TOUR
of Long Island

DR. JOANNE S. GRASSO

THE
History
PRESS

Published by The History Press
Charleston, SC
www.historypress.com

Cover portrait of George Washington courtesy of the Library of Congress.

First published 2018

Manufactured in the United States

ISBN 9781625859556

Library of Congress Control Number: 2018936077

To George Washington, my friend in history, whose dedicated leadership brought this fledgling nation through the American Revolutionary War and into the new American era as our first President.

CONTENTS

Acknowledgements

There is a wealth of knowledge to be obtained from libraries, archives and historical societies on Long Island. These venues serve the greater purpose of preserving the history of Long Island, as well as American history in general. I cannot express my gratitude enough to the following sources that gave me the ability to write this Long Island history.

I would first like to thank all those people who enjoyed my first book, *The American Revolution on Long Island*. You helped inspire me to write another book, with hopeful enthusiastic results as well.

The Fred W. Smith National Library for the study of George Washington was once again a tremendous help in obtaining collective information about George Washington beyond what I could find individually. The Diaries of George Washington formed the initial, integral part of this great man's life and what he saw and how he viewed Long Island in the immediate post–American Revolution year of 1790. Additionally, Mary Thompson of this library was a great asset in obtaining research I requested about George Washington, taverns and Birthnight Balls.

I spent hours at the Long Island Studies Institute (LISI) at Hofstra University. The librarian/archivists are helpful and congenial, and the vertical files were of immense help.

Danielle Apfelbaum, formerly of the Wisser Library at the New York Institute of Technology, aided me greatly in formats for writing this book. After the writing, the logistics of putting the information into a certain format is most important. I wish her well in her own education.

The Manhasset Public Library archives and the extensive work of Antonia Mattheou to rework the archive shelves is greatly appreciated. The library director, Maggie Gough, and her associates are always gracious in allowing me use of the materials in the archive room.

The Westbury Library's The Cottage (The Historical Society of the Westburys) has been very generous several times in allowing me to use its incredible resources. Susan Kovarik, the librarian and archivist at the Cottage, is to be thanked for her continued support.

Washington's Headquarters State Historic Site in Newburgh, New York, gave me valuable oral and printed information about Washington's time there at the end of the Revolutionary War.

Vanessa Nastro of the Port Washington Library's Local History Center was very helpful in providing me initial access to the collection and showing me the wider Long Island collection. The accessibility of this collection was invaluable. Also thanks to Jeff Zeh for his help.

I used the Hempstead Public Library's Long Island Collection for extensive local information. One of the many items in this collection was about the slavery statistics on Long Island.

Andrea Meyer of the East Hampton Library, Long Island History Collection, was once again very helpful in obtaining specific written and image information for my book. There should be more librarian/archivists like her.

I spent a lot of time at the Copiague Library going through the Long Island history books and finding a lot of useful material.

The Mineola Library has a small but concentrated amount of Long Island information that I used and a great supportive reference librarian and assistant director in Cathy Sagevick, who was very helpful with the material and in allowing me to use material for my research.

The Patchogue-Medford Library was very helpful over the phone, online and electronically. It has an extensive Long Island history collection, which was a pleasure to access.

I was very pleased to be able to use the Smithtown Library, Long Island Room, with the help of Caren Zatyk, the archivist, going through its vertical files and obtaining books to interlibrary loan. Caren was very nice and very helpful as I pored through the files.

The Huntington Town Historian's Office, with Robert Hughes as Town Historian, was very gracious in allowing me to access the many vertical files there and obtain numerous copies for my reference. Additionally, there was a great history exhibit, which rotates occasionally.

My thanks to Melanie Dershowitz of the Oyster Bay Historical Society, who prepared a table ahead of my visit with many books to look at for my research. There is a preponderance of historical material in the center next to the Earle Wightman House, where the Society resides.

It's always a pleasure to use local libraries that contain a concentrated amount of information for their local area, as well as general information for Long Island history. The Glen Cove library and its local history librarians, Carol Stern and Ellen Quasha, were very helpful with that concentrated amount of information.

I spent some wonderful time engrossed in the Roslyn Bryant Library's Bryant Room, which contains an enormity of Long Island history of all eras. There were many files and images for me to go through for information. Additionally, the room itself is a historic wonder from another era. Thanks to Carol Clarke for all her help.

The Roslyn Landmark Society preserves the history of Roslyn through such events as the House Tours. It is a beautiful village with many well-preserved homes and quaint shops that speak to an earlier era. Howard Kroplick, Town Historian for North Hempstead, was particularly gracious in sending me images and information from his own resources and for helping with further information.

My thanks to a wonderful man, William F. Taylor, docent of St. John's Episcopal Church in Oakdale. He gave us an in-depth tour of the historic Revolutionary-era church and the attached small cemetery. It was a real blessing happening upon him while we were there.

Fred Blumlein, retired professor and current trustee of the Cow Neck Peninsula Historical Society in Port Washington, once again gave me valuable information for this book. He was gracious enough to give me this information when I needed it and allow me to once again use his images of the Sands-Willet House in Port Washington for this book.

Thanks to my sister Janice, for accompanying me to many of my book talks for the first book and picture-taking trips for this book, as well as for listening over and over again to hours of my love of George Washington and all things from the American Revolution.

I have wonderful supportive, spiritual friends who are always encouraging me on my writing journey and accomplishments in life. They are the backbone of life.

Finally, thank you to The History Press for allowing me to continue to indulge in my lifelong love of the American Revolutionary era and the Revolutionaries themselves by publishing this book.

INTRODUCTION

There had been both a leanness and a hope in the new American spirit between the Treaty of Paris on September 3, 1783, and the inauguration of George Washington as the first president on April 30, 1789.

The Battle of Long Island, which took place in Brooklyn, led to a severe devastation due to the occupation of the British afterward for seven years. The battle had been the "first major defeat of the Revolution. The Continental Army consisted of unpayed [sic] untrained men without uniforms. The untrained men lacked discipline and in some cases no shoes and were almost always starving. The Americans fought the enemy bravely, but they were overwhelmed by the tremendous British forces. Over 2,500 American men were killed, wounded or captured during the Battle of Long Island. The battle was the largest engagement of the American Revolution."[1]

At the end of the war, "as freedom became more certain, many Tory families, fearing the wrath of a victorious America, fled Long Island and other parts of the country."[2] The departure from Long Island of Loyalists, slaves and, finally, the British would leave the island decimated and in debt, like many other areas.

The new United States of America was also in serious debt from eight years of the Revolutionary War. This caused a series of problems, including the Newburgh (New York) Conspiracy, also called the Newburgh Addresses, on March 10 and March 12, 1783. The Newburgh Conspiracy had been brewing for quite a while. In January 1783, army officers encamped at Newburgh, New York, addressed the Continental Congress

with their complaints of lack of pay, food, clothing and pensions. "Their failure to obtain assurances of payment of sums owed officers and to secure a commutation of the pension for 6 years, full pay (rejected 25 Jan. by Congress) led to the first anonymous address to the officers of the army circulated at Washington's main camp near Newburgh, NY."[3]

As Washington observed, "I cannot help fearing the result of reducing the army, where I see such a number of men, goaded by a thousand stings of reflection on the past, and of anticipation on the future, about to be turned into the world, soured by penury, and what they call the ingratitude of the public."[4]

On March 11, 1783, an anonymous letter was written by Major John Armstrong to the officers under Washington, encamped in Newburgh. In it he appealed to the officers, saying that his "past sufferings have been as great and whose future fortune may be as desperate as yours" and that "he loved private life, and left it with regret." He then appealed to their frustration and exhaustion: "After a pursuit of seven long years, the object for which we set out is at length brought within our reach! Yes, my friends, that suffering courage of yours, was active once—it has conducted the United States of American through a doubtful and a bloody war! It has placed her in the chair of independency, and peace again returns to bless—whom?" He then went on to stir them into a frenzy of animosity toward the Continental Congress by asking them to consider "what you can bear, and what you will suffer."[5]

George Washington had found out about the meeting that was supposed to be on March 1, 1783, and stopped it, instead calling for a meeting on March 15. Washington went in person to address the meeting. Both his humility and his directness of tone dissolved the situation:

> On March 15, the officers gathered and [General] Gates stepped forward to chair the proceedings. However, he was interrupted when Washington entered the room unexpectedly and said he wished to address the meeting. He denounced the [anonymous] address's author, adding that his plan had "something so shocking in that humanity revolts at the idea....My God!, [he continued], What can this writer have in view, by recommending such measures! Can he be a friend to the army? Can he be a friend to the country? Rather is he not an insidious foe?"

Washington implored them to "give one more distinguished proof of unexampled patriotism and patient virtue" by placing their full confidence in the purity of the intentions of Congress.[6] Washington then took out a second

letter. It is speculated that he could not read the handwriting of Virginia Congressman Joseph Jones and that it was getting dark. Washington mistook murmuring in the room for impatience and took out a pair of spectacles from his breast pocket: "Gentlemen, you must pardon me. I have grown gray in your service and now I find myself growing blind."[7]

It had been a long war, and the final treaty was yet to be revealed. Both Washington and his officers had endured much during those eight years. Washington's humility in putting his spectacles on in front of his officers did more to establish an atmosphere than did those letters. It was an era of suffering, and Washington showed himself human and like them. This simple act of putting on his spectacles did more for Washington than his words could. Only those in Washington's military family knew the General lately required spectacles to read.[8] In the "Critical Period" between 1783 and 1789, from the ratification of the Articles of Confederation to the new United States Constitution and the first presidency, the new nation endured exorbitant debt totaling trillions of dollars in today's money. During that period, millions were owed to national and state governments, foreign governments such as France and farmers and other creditors by Washington's army for food, supplies and horses.

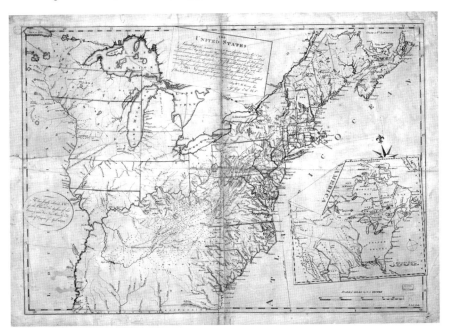

Map of 1783 United States. *Library of Congress.*

"A debt of $70 million lay on the shoulders of a wasted people, alongside the promises of the dead 'continental money' to pay more than $200,000,000 more. About $44,000,000 of the live debt was owing by the general government, $10,000,000 in Europe, and the remainder by the individual States."[9] And then there was Shays' Rebellion, which had as much to do with debt as anything.

There was considered a "loose union" of states under the Articles of Confederation. In fact, in Article III of the document, it was called a "firm league of friendship." There were several difficulties with this document, including its inability to raise taxes or control commerce. Farmers were hardest hit, particularly Massachusetts farmers. Since taxes were to be paid in cash and many farmers could not pay, they lost their farms or were sent to debtors' prisons.[10]

The rebellion lasted from August 1786 to January 1787. About 1,500 farmers marched on the Northampton courts in August and in September, and Daniel Shays, a Revolutionary War officer, closed the Springfield Courthouse—both events were to prevent foreclosures of farms. By January, 1,200 militia had been called out. Small arms were used against the continued rebellion, and cannons left twenty wounded and four dead.[11]

The enormity of the problem of post–Revolutionary War debt spilled over into every area of life. George Washington, upon hearing of Shays' Rebellion, was horrified. He resolved to get commerce back on track, beginning with the 1785 Mount Vernon Conference.

After the Revolutionary War ended, states became contentious over jurisdiction and commercial rights. Maryland and Virginia were locked in a struggle over navigation on the Potomac and Pocomoke Rivers and the Chesapeake Bay.

When a January attempt to resolve issues between those states did not materialize, Washington invited the representatives and state commissioners to a Mount Vernon Conference in March 1785. "Commissioners from Maryland and Virginia met at Mount Vernon in March 1785 to discuss fishing rights and the regulation of commerce on the Chesapeake Bay and its tributaries. The result was the Compact of 1785, the first mutually binding agreement of its kind between two states."[12] The compact's thirteen articles addressed toll duties, vessels of Virginia, vessels of war, laws for fishing, piracies and lighthouses, among other things.[13]

As the political conferences progressed from Mount Vernon in 1785 to Annapolis in 1786 and then the Constitutional Convention in 1787, George Washington would play a greater political role in the formation

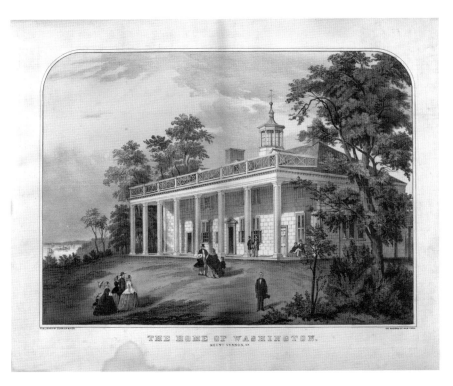

Mount Vernon, George Washington's home, Virginia. *Library of Congress.*

of this country, leading to his presidency. Washington's presence at the Constitutional Convention lent an air of authority and legitimacy to the proceedings. His leadership experience and forthright courage in battle readily prepared him for the next stage in his life.

This book is not simply a travelogue or a tour book of historic Long Island. Through a combination of diaries, letters and accounts, it is a scholarly attempt to depict the movements of the first president of the United States in touring Long Island in 1790, a transitional period for the man. This is a geographical setting he had left in great haste almost fourteen years before, in 1776, in a disastrous attempt to hold on to Long Island for the Revolutionary Patriot cause. The last time George Washington had been on Long Island prior to this grand tour in 1790 was a retreat from the Battle of Long Island in August 1776.

In 1790, Long Island was redefining itself after the American Revolutionary War and the destruction from occupation. A new era was coming about, the American era, and George Washington's presidential tour would signal that

new era. Rebuilding was taking place. Towns and cities were experiencing new growth at the time of the arrival of the first president on Long Island.

I undertook this project about George Washington on Long Island from a love of both George Washington and the American Revolutionary War since I was a child, along with a love of Long Island history, particularly American Revolutionary history. Hence, this book is intended to be mainly historical rather than a contemporary travelogue of Long Island.

Many of the images used in this book were taken by me of the places where George Washington visited or stayed. Because almost all of these buildings no longer exist but have a sign marker or plaque to designate his stop, that is the image used.

I set off material from Washington's diary entries in a special appearance throughout the book and also included the full-length version in the first appendix. Note that all throughout the diary entries there is cryptic and sometimes creative spelling by Washington. That is to be expected of someone traveling and who is perhaps not familiar with the area. There would not have been an abundance of street signs and other notations to enhance the geography either. Additionally, there were capital letters and other bits of punctuation used by Washington in sentences that might not be used today. Some historians argue that in this period of history, the use of capital letters beyond proper names or the beginning of sentences denote an emphasis on that particular word.

I have included national and local government documents in the appendices in the back of this book as well. Government documents are one of the best ways to study American history. The appendices are separated into four sections: Full Diary of George Washington, April 20–24, 1790; George Washington Documents, 1789–1790; National Documents, 1789–1790; and Local (Long Island) Government Documents, 1790. They generally do not require a translation, and they are written in a time when a particular event happened.

In the last chapter, "George Washington's Legacy on Long Island and the Other Founders on Long Island," I did not include information about what some historians called the Benjamin Franklin Mile Markers in Suffolk County. There has been controversy over the years whether these mile markers, which still exist in some areas, were instead from a later period in the early nineteenth century. According to the Southold Historical Society, that is the case.

George Washington looms larger than life in American memory. When Richard Henry Lee said of Washington upon our first president's death in

December 1799, "First in War, First in Peace, and First in the hearts of his countrymen,"[14] Lee could also have been describing a generation of Americans like me after the Revolutionary generation who would still hold Washington as first in their hearts.

George Washington came back to Long Island in 1790 at a time of great rebuilding and restoration. Although a few centuries have passed since his last visit in 1790, his legacy lives on here both physically and inspirationally. Washington had a vision for Long Island as part of this new country, and this vision would be made evident in his diary entries. He would make other tours in New England and in the southern states in the first few years of his presidency. However, Long Island was especially poignant and triumphant because of the disastrous but providential departure fourteen years earlier at the end of the Battle of Long Island.

GEORGE WASHINGTON'S
1790 NEW YORK CITY

George Washington made a triumphal journey to New York City for his inauguration. As president-elect, and unanimously voted on, a notice was sent to Mount Vernon on April 14, 1789, telling him that he was elected as first president of the new United States of America.

Washington had gone to Annapolis at the end of the Revolutionary War to resign his commission to the Continental Congress. "You retire, added he, from the theatre of action with the blessings of your fellow citizens; but the glory of your virtues will not terminate with your military command; it will continue to animate remotest ages."[15]

After Washington left and arrived home on Christmas evening, he wrote a letter to Governor Clinton. "The scene is at last closed," said he, "I feel myself eased of a load of public care. I hope to spend the remainder of my days in cultivating the affections of good men, and in the practice of the domestic virtues."[16] Washington had expected to go home to Mount Vernon and enjoy the remainder of his days there. However, the events of the Critical Years would require his return to public life and his journey northward to be inaugurated in New York City.

New York City in 1790 was alive with post-Revolutionary rebuilding. The British had evacuated the city on November 25, 1783, now a day of celebration called Evacuation Day. Due to the British occupation at that time, the population of New York City had decreased to about eleven thousand, half of what it was before the Revolutionary War. As the rebuilding continued, by 1786, the population was higher than it had been

before the war. The population continued to grow, and by the latter part of the 1790s, it was over sixty thousand.[17] "It took the town fully four years to get over the mischief done by the soldiers, but then having regained most of its lost resources, it went forward with a stride that astonished the rest of the country, including Philadelphia, at that time the largest city in the colonies. No one was more struck with the change than Washington when he returned in 1789 to be inaugurated President."[18]

New York City as the first Federal capital was ostensibly a work in progress. There were serious concerns over whether it was the appropriate geographic area for the capital since it was more north than central in the new thirteen states. New York had divided loyalties to the Constitution, which was now in the adoption phase of going through the thirteen state legislatures. Congress had suggested several other cities as sites for the new capital, among these Philadelphia, Baltimore and somewhere in the Potomac area. Part of the decision would be based on New York's ratification of the Constitution.[19] The Constitution was still being approved while George Washington was on his April 20–24, 1790 Long Island tour. Delaware was the first state to approve it, on December 7, 1787, while Rhode Island was the last state to approve it, on May 29, 1790.

When Washington arrived for his inauguration, it was "on a barge manned by thirteen men in white uniforms, followed by a grand naval procession."[20] His inauguration would be in Federal Hall, which is in lower New York City at the corner of Wall and Broad Streets. Washington wore "a suit of brown cloth manufactured in Connecticut (which he bought to encourage American industry), with silver buttons decorated with spread eagles, and standing on a half-enclosed, open-air balcony on the second floor."[21]

The city was alive with spectators. All areas were filled with people cheering the inauguration of the new president. Many people from all over the new states came to witness the event. Visitors stayed in overflowing hotels and private residences. Gunfire filled the air. Everyone from farmers to politicians packed the streets. The rivers and Long Island Sound were alive with ships and boat activity.[22]

Washington rode from his home in an elaborately decorated coach with coachmen. Every detail was organized into a spectacular event. As he ascended to the second floor of Federal Hall, he met Vice President John Adams, who had been installed two days earlier. Washington went from the Senate to the balcony, where the crowd below cheered for him. Earlier, he had been overcome by emotion and had to sit briefly. Chancellor Robert Livingston administered the presidential oath. Washington used a Bible

from a nearby Masonic Lodge. He spoke the words from Article II, Section I of the new United States Constitution: "I do swear (or affirm) that I will faithfully execute the office of President of the United States, and will to the best of my Ability, preserve, protect and defend the Constitution of the United States." After he kissed the Bible, he added, "So help me God!"[23] (See Appendix III.)

Washington had a well-prepared inaugural address, which he gave after he took the oath of office. He exhibited humility, deep concern and a knowledge that he had been honored by the choice of him as the first president. He addressed "the magnitude and difficulty of the trust to which the voice of my Country called me." He went on to mention the "Great Author" and how "No People can be bound to acknowledge and adore the invisible hand, which conducts the Affairs of men more than the People of the United States." He addressed his love for his country in stating, "I dwell on this prospect (of private morality and the pre-eminence of a free Government) with every satisfaction which an ardent love for my Country can inspire."[24]

Washington saw in himself and his purpose a divine appointment with the new nation, one that was reluctantly accepted, yet his country had called him into service again. He was tested on the battlefields and had developed strong leadership skills over years and miles.

The new Federal capital would not only be the seat of the Constitutional government but also the home to many officeholders. George Washington's first home was on Cherry Street in the spot that is now one of the stanchions of the base of the Brooklyn Bridge on the Manhattan side. This home was smaller and not adequate for his needs, so he later moved to the McComb house at 39 Broadway. His Cherry Street address was where he received visitors, and that "took up all his time from early morning till night."[25] He occupied this address from April 25, 1789, to February 23, 1790.

Washington's Cherry Street presidential mansion was on the corner of Pearl and Dover Streets and was a short distance to Federal Hall. "This was considered uptown to Revolutionary era New Yorkers, and the White Colonial home, built in 1770, was surrounded by other sumptuous houses overlooking the East River. In fact, Washington's neighbor, at 5 Cherry Street, was John Hancock. DeWitt Clinton would later reside in the former Washington home."[26]

There had been cheery trees, gone by the time Washington lived there. The house "was built by Walter Franklin, a merchant of New York City. It was three stories of brick, with small-paned windows; its main entrance

George Washington Second Mansion sign, New York City. *Author's photo.*

led to by half a dozen stairs on either side of a small porch; its doorway fitted with a heavy knocker of brass." Samuel Fraunces was Washington's steward and the same person who owned the tavern where Washington said goodbye to his officers on December 4, 1783, at the end of the Revolutionary War.[27]

Washington's move to the McComb Mansion proved more convenient. It was six stories high and considered a "wonderful building." Washington "celebrated his birthday in the year 1790 by moving into his new residence."[28]

Martha Washington had come to New York City about one month after George Washington's inauguration. She came with her two grandchildren, Eleanor and George Washington Parke Custis. "[M]any of the most distinguished men of the country resided here, and there was plenty of society life in town."[29]

Washington was coming to be inaugurated in a city that needed rebuilding. Commerce needed to be reinvigorated and solidified in its currency and trade. "On the first day of January 1789 New York City had not yet fully recovered from the effects of the great fires of September 21st 1776 and of August 3rd 1778 nor from its occupation by the British during the seven years which ended on the 25th of November 1783." Churches such as Trinity Church, the Lutheran Church on Rector Street and the Middle Dutch Church all had to be rebuilt. After several years of rebuilding, New York City "went forward with a stride that astonished the rest of the country,

including Philadelphia, at that time the largest city in the colonies. No one was more struck with the change than Washington when he returned in 1789 to be inaugurated President."[30]

George Washington wrote in his diary that he often "went to Trinity Church in the forenoon—and wrote several private letters in the afternoon."[31] Trinity Church was originally erected facing the Hudson River. In its three-hundred-year history, it was first granted a charter in 1697 and then given a six-year lease after construction. Since the city's population had doubled by 1750, two more chapels were built: St. George's Chapel, which no longer exists, on the east side of lower Manhattan and St. Paul's Chapel north of Trinity Church on the corner of Broadway and Vesey. In the Great Fire of 1776, the first Trinity Church building was destroyed, but St. Paul's Chapel was saved by a bucket brigade.[32] "[T]he burnt sections [of the city] extended up both sides of Broadway, where the remains of Trinity Church reared a ghastly steeple, to Rector Street; except for a half dozen houses left standing near the Battery."[33]

"Until the second Trinity Church was rebuilt in 1790, many, including George Washington, made St. Paul's their home. On April 30, 1789, after Washington took the oath to become the first President of the United States, he made his way from Federal Hall on Wall Street to St. Paul's Chapel, where he attended services,"[34] "The site of St. Paul's Chapel was quite in the outskirts of the city. The same year in which the foundation stone was laid, the lot on which

Trinity Church sign, New York City. *Author's photo.*

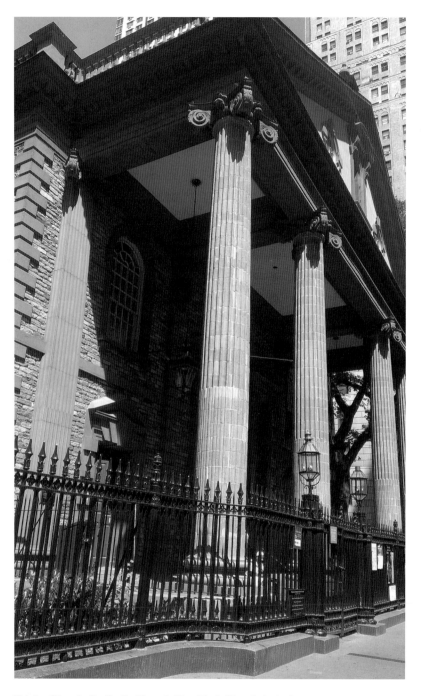

Trinity Church, St. Paul's Chapel, New York City. *Author's photo.*

it stands had been ploughed up and sowed with wheat. When the building was finished, by the completion of the steeple in 1794, it was considered the most elegant and imposing church edifice in the city. Washington attended St. Paul's for two years while the newly created city of Washington, DC was under construction and New York functioned as the nation's capital. He sat in the specially designated Presidential pew at St. Paul's."[35]

In George Washington's 1790 New York City, Broadway was the handsomest street and the greatest thoroughfare. South Street was occupied by shipping merchants between Battery to Roosevelt Street, with wholesale grocers and commission merchants between Front and Water Streets. Pearl Street was the "peculiar and favorite resort of wholesale dry goods merchants, from Coenties Slip to Peck Slip. Wall Street, between Pearl and Water Streets were one area of auction stores."[36]

George Washington was not only an expert horseman but also proficient at the contemporary dances and an avid attendee at the theater. In New York City, he went to the sole theater, the John Street Theatre. The British had the theater built during occupation for their own "amateur" productions. Washington Parke Custis, grandson of George Washington, noted in his *Recollections and Private Memoirs of the Life and Character of Washington* that the theater "was so small that the whole fabric might easily have been placed on the stage of some of our modern theatres. Boxes were set apart for the President and Vice-President, and the playbills were inscribed 'Vivat Republica.'"[37]

The Federal government situated in New York City for the year was also the home to other members of Washington's cabinet, like Secretary of State Thomas Jefferson and Secretary of the Treasury Alexander Hamilton. Jefferson's home was on 57 Maiden Lane, and Hamilton's was on 33 Wall Street.

One week after Jefferson's arrival into New York City on March 22, 1790, to take over his duties as Secretary of State under George Washington, Jefferson wrote, "My first object was to look out, in the Broadway, if possible, as being the center of my business. Finding none there vacant for the present, I have taken a small one in Maiden Lane." He paid "one hundred pounds per annum New York currency, paiable [*sic*] in specie quarterly." He resided at the house for a little over five months before returning home to Virginia and then to the next capital, Philadelphia. The Compromise of 1790 was worked out while Jefferson lived in this house. He stated, "Congress had been long embarrassed by two of the most irritating questions that ever can be raised among them. 1. The funding the public debt, and 2. The fixing on a more central residence."[38]

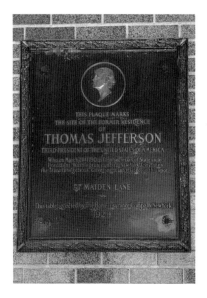

Thomas Jefferson Mansion sign, New York City. *Author's photo.*

The problem of where to have a permanent capital turned into a sectional division, with the southern states wanting the Potomac area and mid-Atlantic and eastern states wanting it farther north. Jefferson and Hamilton met on a street in New York City and developed the compromise. Hamilton "depicted the national jeopardy in woful [*sic*] colors, and movingly besought Jefferson to use his influence with some of his friends to save the union." Jefferson replied that he was really a stranger to the whole subject "but that the preservation of the country touched him nearly, and he begged Hamilton to dine with him the next day."[39]

Jefferson and Hamilton were political foes, and this compromise would afterward rankle Jefferson. He felt he had been "tricked" by Hamilton in aiding his "political opponent."[40] Alexander Hamilton was the nation's first Secretary of the Treasury. He was bright, and under Washington's guidance, he was an experienced aide on the battlefield and now in the new government. Washington's administration had very eclectic leaders, and Jefferson and Hamilton were as different as any two officials in one administration could have been.

In many ways, Hamilton was different from his fellow founding fathers, particularly his mentor, George Washington. Hamilton was the illegitimate son of a Scottish merchant, not landed gentry like Washington. He emigrated from the island of Nevis in the Caribbean rather than being a natural-born citizen in the former colonies here. Hamilton gravitated more to the Federalist ideal of manufacturing and urban life. He was also a northerner and from one of the greatest cities in the new nation, New York. His last home, the Grange, still exists in New York City, despite a few moves, deterioration and multiple ownerships. It has been renovated and is operated under the auspices of the National Park Service.[41]

Hamilton "seemed born with a mastery of words, a rare gift of expression....His power as an actor was unsurpassed in any assembly that called it forth, but with a very few exceptions he did not appear before the

multitude. He swayed the leaders and won them to his leadership. There was little of fancy in his speeches, scarcely any appeal to the emotions, but he spoke with enthusiasm and an intensity of conviction."[42] Hamilton's economic programs, such as the 1790 Report on Public Credit, proclaimed "the public faith and establish the Nation's credit."[43]

Hamilton had both detractors and supporters, and whatever the speculation about his personality, background and reasons for establishing economic stability programs, he was brilliant and steadfast in his loyalty to the new president and the new nation.

By the time of Washington's inauguration, New York City had multiple churches of different denominations. There were about fifteen churches; a Jewish synagogue; prisons; a poorhouse; a hospital; a theater; different cemeteries for Christians, Jews and Africans; a government building; a college; and various other buildings, both private and commercial, pertaining to a city on an island bordered by two large rivers. New York City was the perfect temporary capital for the government, as well as a city that was growing in geography and population.

George Washington received visits from noted political leaders in his first year as president in New York City. He created many "firsts" in his administration, including "Mr. President" as a title for his office. He held levees (receptions), only vetoed two bills in his eight years in office and only served two terms when there was no term limits for presidents. New York City would be his first home in the new government and the first home of the government under the Constitution.

On August 30, 1790, President Washington and the First Lady left New York as they came, on a barge across the Hudson at Macomb's Wharf, on the North River. "Washington would never again see the city he had both lost and liberated."[44] However, Washington was getting ready to cross the river onto Long Island and spend the next five days on a grand tour of the once-occupied island:

Alexander Hamilton grave monument, New York City. *Author's photo.*

He rode in a coach, drawn by four grey horses, with riders. It was one of the best of its kind; heavy and substantial. The body and wheels were of cream color, with gilt mouldings; it was upon leather straps resting upon iron springs. Portions of the sides of the upper part, as well as the front and rear, were furnished with neat black leather curtains. Upon the door Washington's arms were handsomely emblazoned, having scroll ornaments issuing from the space between the shield and the crest; and below was a ribbon with his motto upon it—"Exitus acta probat." Upon each of the four panels of the coach was an allegorical picture emblematic of one of the seasons.[45]

Stephen Decatur also noted that "Washington neglected to say who accompanied him, but Major William Jackson, his military aide, went along and probably four servants—coachman, postilion, valet and footman, the last-named to be used for a messenger, if needed. Tobias Lear, then the President's chief secretary, was not on the tour; he was away on leave getting married. The [President's] account books contain but one entry for April 20, and then no further item until April 26, the longest gap to be found anywhere in them."[46]

BROOKLYN'S LEGACY AND WELCOME

> About 8 o'clock (having previously sent over my Servants, Horses, and Carriage), I crossed to Brooklyn and proceeded to Flat Bush—thence to Utrich—thence to Gravesend...at the house of a Mr. Barre, at Utrich, we dined.[47]

Mr. Barre was not listed on the 1790 census, but a William Barry is listed. "Washington's traveling establishment consisted of two gentlemen on horseback as escort, a coach with four horses in which the President rode, followed by Washington's cook and the cook's wife in an old fashioned chaise, drawn by one horse, with the culinary utensils suspended from the axle."[48]

Some historians say that Washington had two purposes to come to Long Island: to thank the spies of the Revolutionary War and to look at the agriculture. To that latter end, Washington did make a foray out to Flushing, Long Island, on October 10, 1789.

His diary noted, "Pursuant to an engagement formed on Thursdays last, I set off about 9'oclock in my barge to visit Mr. Prince's fruit gardens and shrubberies at Flushing, Long Island. The Vice-President (John Adams), Governor of the State (George Clinton), Mr. (Ralph) Izard (Senator, South Carolina), Colo. (William Stephens) Smith (son-in-law of Adams), and Majr. (William) Jackson (military aide)."[49]

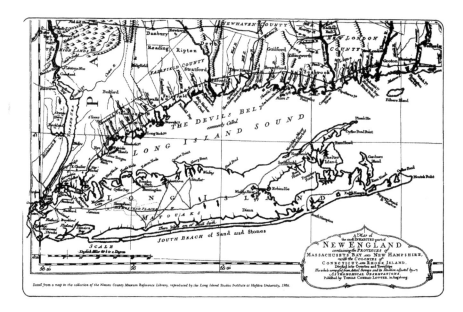

Map of Long Island. *Hofstra Long Island Studies Institute.*

The Mount Vernon website noted that "George Washington studied and implemented improved farming methods throughout his life. In fact, he thought of himself first as a farmer. George Washington devoted his life to the improvement of American agriculture. While his initial interest in farming was driven by his own needs to earn a living and improve Mount Vernon, in later years Washington realized his leadership and experimentation could assist all American farmers."[50]

"Before there was a formal parks system in Queens County, Long Island, the distinct communities that today comprise the borough planted the seeds. As early as 1737, Queens established its tradition of caring for trees, when Flushing was home to the nation's first nurseries."[51]

A few days before the visit to Flushing, Washington had written in his diary:

> Had conversation with Colo. [Alexander] Hamilton on the propriety of my makg. A tour through the Eastern states during the recess of Congress to acquire knowledge of the face of the Country the growth and Agriculture thereof and the temper and disposition of the Inhabitants toward the new government who thought it a very desirable plan and advised it accordingly.[52]

George Washington's first stop on his grand tour of Long Island, then, would be in Brooklyn. Brooklyn's recent history had been treacherous and disastrous for the Patriots. "During the whole period of the Revolution Brooklyn had been peculiarly disturbed. More than any other of the county towns, it had been distracted and prostrated. Farmers had been pillaged and the property of exiled Whigs given over to Tory friends of the Governor. Military occupation naturally resulted in great damage to property. After the evacuation, Brooklyn's farmers and tradesmen at once turned their attention to the restoration of the orderly conditions existing before the war."[53]

Brooklyn and its environs in Kings County went through changes in many areas of life, including political, economic and social. Flatbush had a taste of the Revolutionary fighting and suffered considerably during the British occupation. The mills became a prominent feature of Flatbush scenery.[54]

Afterward, on July 2, 1791, public notice was given of the plan for building a county courthouse and jail at Flatbush. Eramus Hall was erected in 1786, its charter bearing the same date as that of the Easthampton Academy. The first public exhibition of Erasmus Hall was held on September 27, 1787, which "was graded by the presence of the Governor of the State, several members of the Assembly, and a large concourse of prominent gentlemen of the vicinity."[55]

"The Legislature was repeatedly called by the Governor's messages to paramount need of having a regular school system throughout the state." Finally, in 1795, that body passed "an act for the encouragement of schools."[56] "The erection of that excellent institution, 'Erasmus Hall,' at Flatbush in 1787, proved that the higher interests of education and morality were appreciated by the inhabitants of Kings County."[57]

George Washington was a traveler all throughout his life. In all phases of his life, he traversed this land for the military, for commerce, with family and now as the President. At age fourteen, he desired to enter the navy after listening to stories from his brother Lawrence and seeing naval ships docked in the area. This adventure was not to be. During a surveying expedition when he was sixteen, he exhibited the same detail in his diary as he did in his travels on Long Island in 1790. Of the Shenandoah in Virginia, he mentioned "delight of the beauty of the trees and the richness of the land in the neighborhood, and of riding through a noble grove of sugar maples on the banks of the Shenandoah."[58] He was always experiencing new adventures, which unbeknownst to him served as experience for when he would be Commander-in-Chief during the Revolutionary War and then president. Such was the case in being out in the wilderness and seeing "a war

party of Indians" that would do a war dance. He soon "became an expert at dealing with these inhabitants of the wilderness."[59]

"The position of public surveyor allowed Washington an occupation, which proved extremely profitable, from the vast extent of country to be surveyed and the very limited number of public surveyors. It made him acquainted, also with the country, the nature of the soil in various parts, and the value of localities."[60] Washington would be the first president to travel outside the colonies when he sailed with his brother on September 28 to Barbados, landing on November 3. "George kept a journal of the voyage with logbook brevity....The brothers [Lawrence and George] were delighted with the aspect of the country, as they drove out in the cool evening, and beheld on all sides fields of sugar cane, and Indian corn, and groves of tropical trees, in full fruit." It was also here where George was stricken with smallpox but recovered, due in large part to the support of friends and Lawrence, who passed on soon after.[61]

George Washington was also chosen early on to lead a command into the Ohio Country. "His woodland experience fitted on for an expedition through the wilderness."[62] He was a man uniquely qualified to keep his thoughts in journals and diaries while he was on the frontier. One of the great lessons he learned during this time was the formalities of dealing with various native groups. All of these experiences helped to prepare him for leadership of the military and travel up and down the colonies turned states during the American Revolutionary War. And now Washington was making a triumphal tour of Long Island.

FLATBUSH was once again given liberty in religion once the Revolutionary War and occupation were over. "On the 6th day of April, in the year 1784, the Legislature of the State of New-York, passed an Act, entitled, 'An Act to enable all religious denominations in this State, to appoint Trustees, who should be a Body Corporate, for the purpose of taking care of the temporalities of their respective congregations, and for other purposes therein mentioned.'" Since the Revolutionary War was over and the occupation finished, the rebuilding of Long Island could begin. There was peace in knowing that religious freedom was once again a part of life in Flatbush.[63] Many churches were renewed and rebuilt after the British and Hessian occupation. By the early 1800s, the Dutch Reformed Church and Episcopal Church had been organized, and church buildings had been built.

Imagine George Washington's feelings at being in the NEW UTRECHT area again—the towns where "during the Revolutionary War the British made their base of operations for the Battle of Long Island, the first large-

scale British invasion of the colonies." "On the grounds of the Dutch Reformed church is a bronze tablet dedicated to a liberty pole: 'This Liberty Pole marks the spot over which the American flag first wave in the town of New Utrecht. The original pole was erected by our forefathers at the Evacuation of the British, November 1783, amid the firing of cannon and demonstrations of joy.'"[64]

"With the close of the 1776 war a new century was at hand for the settlement of New Utrecht. The Seventeenth Century witnessed much for the old Dutch township, but the Eighteenth Century closed with a still more remarkable list of happenings. Scattered homesteads and villages became more united by reason of the march of progress. Many inhabitants of the 1700 period were left in the township. New ones came."[65]

Washington in his diary entry for April 20, 1790, wrote a little more extensively about Mr. Barre and his farming:

> At the house of a Mr. Barre at Utrich we dined. The man was obliging but little else to recommend it. He told me that their average Crop of Oats did not excel 15 bushls. to the Acre but of Indian Corn they commonly made from 25 to 30 and often more bushels to the Acre but his was the effect of Dung from New York (about 10 Cart load to the Acre)—that of Wheat they sometimes got 30 bushels and often more of Rye.[66]

The 1790 census report for New Utrecht contains no entry for a man named "Barre," but it does list a William Barry, whose household consisted of eight whites and five slaves.[67]

Washington showed great attention to detail in his April 20, 1790 diary entry for the farming of Mr. Barre. Washington often displayed a meticulous attention to detail, whether in correspondence to his officers and Congress during the Revolutionary War; giving written instructions to his executive secretary, Tobias Lear; or writing journal entries while on Long Island. On an earlier crest of arms, which Washington used for book plates in his life, and to which he added wheat spears, there was an indication that "the bearer owned land and was a farmer....He was born on a plantation, was brought up in the country and until manhood he had never seen a town of five thousand."[68] He was one of the first American experimental agriculturalists, always alert for better methods, willing to take any pains to find the best fertilizer, the best way to avoid plant diseases and the best methods of cultivation. "If he were alive to-day, we may be sure that he would be an

active worker in farmers institutes, an eager visitor to agricultural colleges, a reader of scientific reports and an enthusiastic promoter of anything tending to better farming and farm life."[69]

In Washington's diary entries of April 7–8, 1785, he stated, "Cut two or three rows of the wheat (cape wheat) within six inches of the ground, it being near eighteen inches high, that which was first sown, and the blades of the whole singed with the frost. Save oats today in drills at Muddy Hole with my barrel plough. Ground much too wet; some of it had been manured, but had been twice ploughed, then listed, then twice harrowed before sowing; which it not been for the frequent rains, would have put the ground in fine tilth. Ploughed up the turnip patch at home for orchard grass."[70]

When Washington did not feel comfortable with his overseers' or manager's attention paid to his crops, he also wrote to Thomas Jefferson, among others, as during his presidency in October 1795, when he noted, "I am resolved, however, as soon as it shall be in my power to attend little more closely to my own concerns, to make this crop yield in a degree to other grain, to pulses, and to other grasses. I wish you may succeed in getting good seed of the winter vetch. I have often imported it, but the seed never vegetated."[71] Interacting with other planters gave him a sense of support while he was away from Mount Vernon for lengths of times, like the years of his presidency. Washington's diaries also served not only as good instruction manuals for other farmers but also as written directives for his overseers and manager, even though it could be a frustrating interaction, maintained first from New York City and then from Philadelphia.

GRAVESEND is the last part of Kings County that Washington noted for his diary for April 20. Gravesend is one of Brooklyn's five original villages and was first settled in 1643 by Lady Deborah Moody. She was British and a female landowner, considered the first in the New World, so this village was deemed British rather than Dutch like the other five Dutch villages; like the others, it was mainly agrarian.[72]

Washington would have experienced different sites as he rode in his carriage through Gravesend. One of these was and is the Charles M. Ryder House, at 32 Village Road North. This house was said to have been built in about 1788 and was being used as a school when Washington visited the area in 1790.[73]

Washington would have been familiar with a rural agricultural area like Gravesend and the community, which would have had a church in proximity: "The first settlers of this town being almost exclusively English the church that was first organized, seems to have no connexion [sic] with the churches

of the Dutch towns, till after the revolutionary war: probably because the most of the inhabitants could not understand their language. If then, they had a church organization at an early period among them, they must have derived their supplies from some other sources. It is also a singular fact that the town records, which cover a period of 200 years, and are nearly entire, afford not the least intimation of a church being erected at an early date."[74]

As Washington was traveling on the roads, he noted in his diary:

> The land after crossing the Hills between Brooklyn & flat Bush [sic] is perfectly level, and from the latter to Utrich, Gravesend and in short all that end of the Island is a Rich black loam.[75]…Brooklyn was incorporated as a village in April, 1816, and became a chartered city in 1834. Williamsburg and Greenpoint were annexed to it in 1855; the towns of Flatbush, New Utrecht, and Gravesend, in 1894; and the town of Flatlands became a ward of the city in 1896.[76]

CHAPTER 3

QUEENS TOWNS

In his diary for April 20, Washington noted:

> The Road until I came within a mile or two of the Jamaica
> Road, called the middle road kept within sight of the Sea, but
> the weather so dull & at times Rainy that we lost much of the
> pleasures of the ride....From Brooklyn to Flatbush is called 5
> miles, thence to Utrich 6—to Gravesend 2—and from thence to
> Jamaica 14—in all this day 27 miles.[77]

Just fourteen years earlier in August 1776, the dull weather from a
Providential fog was a blessing for getting Washington's troops off Long
Island while retreating from the largest battle of the Revolutionary War, the
Battle of Long Island.

JAMAICA was instrumental in the Battle of Long Island. Both Jamaica
Pass and Jamaica Road were focal points for troop movements of both
sides. "Colonial Queens was made up of the towns of Jamaica, Flushing,
Newtown, Oyster Bay and Hempstead. The last two towns today are part of
the present-day Nassau County."[78]

Jamaica Pass was easiest for the British to access. "The British plan was
well thought out, and with the advantage of an overwhelming force, they
would succeed, but not before Washington's troops gave a good showing.
One of the events included the positioning of the troops through the Jamaica
pass."[79] Jamaica had formed a company of Minutemen in the fall of 1775,

and it came with a "promise to be obedient to the officers and subject to the resolutions and directions of the Continental Congress and Providential Congress of the colony."[80]

"On Monday December 8th 1783 the glorious event of peace was celebrated at Jamaica by the Whigs of Queens county. At sunrise a volley was fired by the continental troops stationed in town, and the thirteen stripes were displayed on a liberty pole which had been erected for the purpose. At four o'clock a number of the gentlemen of the county, and officers of the army who were in the neighborhood, sat down to an elegant dinner, attended by the music of a most excellent band formerly belonging to the line of this State. After thirteen toasts, the gentlemen marched in column, thirteen abreast, in procession through the village, preceded by the music and saluting the colors as they passed.[81]...In the evening every house in the village for several miles around was most brilliantly illuminated, and a ball given to the ladies concluded the whole. It was pleasing to view the different expressions of joy and gratitude in every countenance on the occasion."[82]

Warne's Tavern is probably related to "William Warne, who is listed in the 1790 census as living in Jamaica."[83] Washington spent his first night on Long Island at Warne's Tavern. It was near the original home that Rufus King, a signer of the Constitution, purchased in 1805 in Jamaica.

NEWTOWN in Queens County also suffered greatly during the Revolutionary War. Although many inhabitants were Loyalists, they were forced to provide supplies for the British soldiers and endure thievery from the Patriots:

Farmers were also subject to many severe regulations and burdens, imposed by the higher authorities. They were required to furnish from year to year, for the use of the army, the greater portion of their hay, straw, rye, corn, oats. Vegetables, and fresh provisions, under pain of being imprisoned, and having their crops confiscated.[84]

...On the evacuation of New-York, Nov. 25th, Jonathan Lawrence, Jun. and other young men of Newtown, rode down to that city, and joined the escort of Gen. Washington, on his taking possession of the town with the American army. It was a proud day for Newtown when her patriotic sons were permitted to return to her embrace from a tedious exile; what inexpressible emotions were enkindled at that first recognition of long-separated-friends. The warm grasp of the hand given in silence, the tear on the careworn cheek, alone told their mutual joy and gratitude. They met on freedom's soil; this gave it zest. Heartfelt were the rejoicings at

the consummation of our liberty. On Monday, Dec, 8th, the Whigs of
Newtown joined with others from all parts of the county in celebrating the
event at Jamaica.[85]

Now six and a half years later, George Washington was traveling through Queens viewing the rebuilding. "Only years of toil and much expense could make good the damage inflicted on the premises of the whigs while in exile. Their dwellings and outhouses dilapidated, fences destroyed, and acres upon acres of valuable timber cut and removed."[86]

The Revolutionary War on Long Island had a "demoralizing effect" beyond the destruction of property. As churches were destroyed, Sunday worship had been desecrated. The moral decline of the British troops spilled over to the citizens. Moreover, the political, social and moral divisions between the Whigs and Loyalists remained even after several years, when the Whigs who returned and the Loyalists who had either stayed or fled and returned much later interacted with one another.[87]

The county of Queens had been divided into the five townships of Newtown, Flushing, Jamaica, Hempstead and Oyster Bay. After the town of North Hempstead was separated from the town of Hempstead in 1784, there were six townships.[88] Even though New York was not evacuated until November 25, 1783, a bill titled "The Act of Attainder and Confiscation" initiated the punishment process four years before evacuation. Loyalists had begun immigrating to Canada by 1782. However, 1783 was the year of the real evacuation, when the "Spring Fleet," twenty square-rigged ships carrying three thousand evacuees, departed for New Brunswick, Canada. The people would found the city of St. John.[89]

FLUSHING had experienced political and physical growth by the time George Washington was inaugurated in April 1789. Courts were opened again after the war. The county seat was established at Jamaica, and a petition was signed for the erection of a new "Court-house." The social and moral decline was evident after British occupation, when scores of "dram-sellers" and "drunken people" lined the entry to the Court-house. The Constitution, after it was ratified by the State of New York on July 26, 1788, was "celebrated in Flushing by a large gathering of people from different parts of the Country." A "colonnade constructed of evergreens was erected on the green. Above the colonnade were the standards of the states that had ratified the constitution."[90]

Alexander Hamilton—George Washington's friend, ally and aide-de-camp in the Revolutionary War—was instrumental in getting the Constitution

ratified in New York through the writing of the Federalist Papers. Hamilton and Washington differed in opinion on public credit. Hamilton felt that "the measures heretofore adopted for the support of public credit had lifted prosperity high." Washington felt it was the "abundant harvests which blessed our country with plenty and the means of flourishing commerce."[91]

Beginning in the colonial era, Flushing was known for its fruit trees and fruit growing. With the Huguenots and, later, the English, markets were created and profits made. Many fruit trees were part of this enterprise, including peach, pear, plum and apple. One of the most successful governors was William Prince, who lived through the years of the British occupation. Owing to the necessity of the fruit trees, General Howe tried to have them protected during the Battle of Long Island in August 1776, but much damage was still done. This was the nursery in Flushing that George Washington visited in 1789. Washington had hoped it would be a better venue, but only six years after occupation, the nursery was still recovering.[92]

Flushing had several historic sites in existence when George Washington traveled throughout Queens. The Bowne House was built in 1661 by John Bowne, a Quaker and first treasurer of Queens County. The Bowne House was also the site of the founding of the Society of Friends, called Quakers. George Washington was a guest in the house after the Revolutionary War occupation. One of the religious sites in existence was the Friends Meeting House, erected in 1719; it was used as a barracks and hospital by the British during the Revolutionary War, and the Quakers held regular services there. A signer of the United States Constitution, Rufus King, owned the King Mansion in King Park.[93] An ambassador to the Court of St. James, King served in the Revolutionary War and the Confederation Congress and as an antislavery advocate.[94]

Of Hempstead, Washington noted in his diary:

> Wednesday, 21st. The morning being clear & pleasant we left Jamaica about eight o'clock, & pursued the Road to South Hempstead along the south edge of the plain of that name—a plain said to be 14 miles in length by 3 or 4 in breadth without. a Tree or a shrub growing on it except fruit trees (which do not thrive well) at the few settlements (SP). Thereon.—The soil of this plain is said to be thin & cold, and of course not productive, even in Grass.—We baited in South Hempstead, (10 miles from Jamaica) at the House of one Simmonds, formerly a Tavern, now of private entertainment for money.[95]

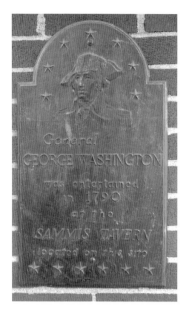

Sammis Tavern plaque, Hempstead. *Author's photo.*

It was long thought that Washington is referring here to the Sammis Tavern, which stood until 1929 at the northeast corner of Fulton and Main Streets, but research shows that in 1790, on the corner diagonally opposite the Sammis, stood Simmonson's tavern, which students now believe was where he stopped to dine, as historian Paul Bailey has noted.[96] "As Washington proceeded to "South Hempstead (now Hempstead), he skirted the south edge of The Plains."[97]

Loyalty to King George in the south of Hempstead and strong Patriot actions in the North "sparked intense antagonism even after the British forces surrendered at Yorktown. As a result, the state legislature approved plans in 1784 which split the towns of North Hempstead and South Hempstead. Later the name of South Hempstead was changed to its original Hempstead."[98]

HEMPSTEAD had several notable homes during and after the Revolutionary War. Rock Hall in Lawrence (originally Far Rockaway) was occupied for a while by Patriot troops. Hempstead had many Loyalists of English descent, and Rock Hall was designed by the same man, Timothy Clowes of Jamaica, who designed St. George's Church, also in Hempstead and affiliated with Loyalists. An elegant home both before and after the war, by 1790, when Washington toured Long Island, the home had been updated to the Federal style.[99]

St. George's Church, a strongly Loyalist church during the Revolutionary War, was privileged to still be in existence after the war. "By the changes wrought by the recognition of our country as an independent nation, the Church followed the fortune of the state in being sundered from the mother country. The connection of the Missionary parishes with the Society for the Propagation of the Gospel, which, for near a century, had been a nursing mother to this and other parishes, was broken. The parish had so decidedly favored the Royal cause that it would have been well-nigh extinguished."[100] But by God's good providence, it suffered less than might have been reasonably expected. "The articles of its Charter made adequate provision

for the exigency which had arisen, and enabled it to enter readily on an independent course of life."[101]

Other notable Hempstead sites during Washington's tour era included the Bedell House, originally built in 1689 and considered "the oldest house in Bellmore," and the Carman-Irish House, built circa 1700 (the second owner was Tillinghast Irish, who came from Tennessee, and the third was Samuel Carman, who was descended from one of the founders of Hempstead Town, John Carman).[102]

In the 1790 census, the Carman family consisted of "Free White Heads of Families including Benjamin, John, Joseph and Samuel," as well as several slaves, listed only as "A," "B," "C" and so on. Other instances of slavery were recorded. In the town of Oyster Bay, an owner, Townsend Hewlett, appeared at the poorhouse with "his Negro Woman Named Rachel Flanders to be set free. She being duly Examined Appears to be under fifty Years of Age and of sufficient Ability to get [her] own Living. now We do by the Authority the Legislature has given us Manumated the said Slave Agreeable to a Law passed the 12th of April 1785 for that purpose and is hereby freed Accordingly."[103] Slavery finally ended in the state of New York in 1827.

Washington noted in his diary:

> From thence turning off to the right, we fell into the South Rd. at the distance of about five miles where we came in view of the Sea & continued to be so the remaining part of the day's ride, and as near it as the road could run, for small boys, marshes and guts, into which the tide flows at all times rendering it impassible from the hight [sic] had also been a public House, but now a private one—received pay for what it furnished—this House was about 14 miles from South Hempstead & a very neat and decent one.[104]

On this leg of his journey, when Washington's carriage "fell into the South Rd. at a distance of about five miles," he was passing through the town now called Merrick.[105]

CHAPTER 4

SOUTH SHORE SUFFOLK COUNTY

B y the time Washington's carriage stopped at Zebulon Ketcham's homestead he was in Huntington South, now called COPIAGUE. Ketcham had been in the Suffolk County Militia during the Revolutionary War, and he was now hosting Washington for a meal. Ketcham's homestead was a "frame, unpainted shingle house that stood near the end of what is now Deauville Boulevard and Montauk Highway [Merrick Road]." Although it was said that the Ketcham house was moved to Amityville, the sign erected by the Babylon Town Board on the site in 1827 states that the house was "razed" in 1857. The original table on which George Washington had dinner is said to be with the Huntington Historical Society.[106]

Washington noted:

> After dinner we proceeded to a Squire Thompson's such a House as the last, that is, one that is not public but will receive pay for every thing it furnishes in the same manner as if it was.[107]

On this second day's drive along the South Road, Washington slept in a second-floor bedroom, which is still preserved. The house was owned also by the Gardiner family, descendants of Judge Thompson.[108]

During the Revolutionary War, Sagtikos Manor was occupied by the British. "Sagtikos is an Indian word meaning 'snake that hisses.' Sagtikos Neck, on which the Manor stands, was known by the English as 'Apple Tree Neck.' The neck of land was purchased from the Secatogue Indians in

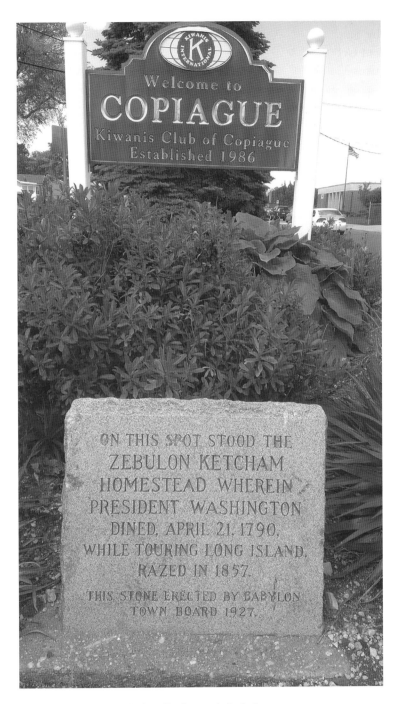

Ketcham Memorial rock sign, Copiague. *Author's photo.*

)hanus Van Cortlandt. As recorded in his personal journal, orge Washington returned to Long island and spent the night Manor."[109] Washington's bedroom for his night there was on the second floor. "British Commander Sir Henry Clinton had slept here a few years earlier during the Revolutionary War occupation and three hundred Hessians had also camped here. A bullet hole is in the attic wall, the bullet 'meant' for the patriot proprietor, Judge Isaac Thompson."[110]

As Washington continued to travel into Suffolk County at the end of the twenty-first of April, he encountered a different farming environment than in Queens. In his diary, he wrote:

> The Road in which I passed to day, and the Country here more mixed with sand than yesterday and the soil of inferior quality;— yet with dung which all the Corn ground receives the land yields on an average 30 bushels to the acre more often.—Of wheat they do not grow much on acct. of the Fly but the crops of Rye are good.[111]

Suffolk County was established in 1683. "In October 1683, the New York General Assembly in New York City divided New York into 12 counties, including Kings County [now Brooklyn], Queens County [originally included Nassau County] and Suffolk County, named after an English county." Suffolk County was two-thirds of Long Island, which is 120 miles

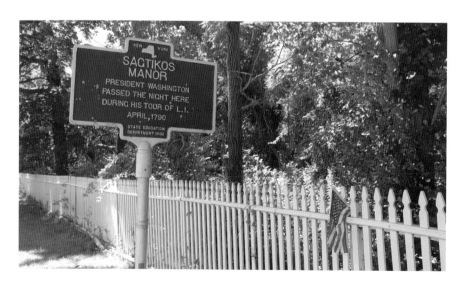

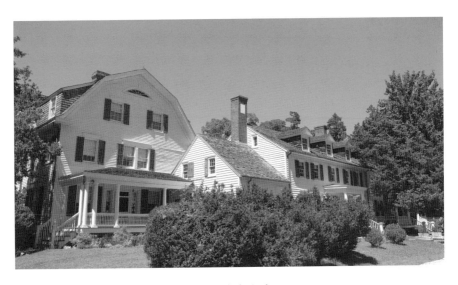

Above and opposite: Sagtikos Manor, Bayshore. *Author's photo.*

long and about 20 miles wide. The area of Suffolk County created was about 1,000 square miles. The original borders were along the same Dutch and English lines created in 1650 where the English had settled the Eastern End of Long Island. This area became Suffolk County, and the Dutch took over the area that is present-day Nassau County.[112] According to the 1790 census, while Washington traveled throughout Long Island, Suffolk County had a total population of 16,440. Some of the local town populations within Suffolk County included Brookhaven at 3,224, Huntington at 3,260, Islip at 609 and Smithtown at 102.[113]

Washington would travel as far as Patchogue on the southern shore of Long island and Setauket on the northern shore, not out on the North or South Forks, but his presence and legacy would be felt all over the island:

> Thursday, 22d. About 8 o'clock we left Mr. Thompson's—halted awhile at one Greens distant 11 miles and dined Harts Tavern in Brookhaven township, five miles farther. To this place we travelled on what is called the South road described yesterday, but the country through which it passed grew more and more sandy and barren as we travelled Eastward, so as to become exceedingly poor indeed, but a few miles further Eastward the lands took a different complexion we were informed.[114]

Washington was soon entering the area of the Great South Bay. It was a beautiful area of wetlands and fishing, as well as the later harvesting of oysters and clams.[115] Washington's personal commerce partially relied on fishing, and he would have been aware of the great resources that this area would produce in the future.

According to historian Kenn Stryker-Rodda, "Green's Tavern was at Sayville, Harts in present Patchogue near Lakeview cemetery on the north side of Montauk Highway, a tombstone memorial marking the site today. The following tradition persists in the Hart family: when Washington arrived, a group of boys were roasting sweet potatoes in a fire by the roadside. The Hart boy, hearing the President's voice, pressed up to the side of his coach and offered a potato, which he received and ate with pleasure. After thanking the boy, Washington presented him with an English shilling that has been preserved in the family."[116]

Greens was a "typical colonial farmhouse at West Sayville and was in excellent condition in the late 1940s. It had been the home of Pettit Green Bates, who was a descendent of the Hart family that hosted George Washington."[117]

Washington was the only authority for details on the agenda of his five-day trip. There were no contemporary newspaper accounts and hence no news reporters to follow his carriage. There is scare mention in any town records in any of the localities of his visit, and there are no accounts of speeches made by local dignitaries on any of his stops.[118]

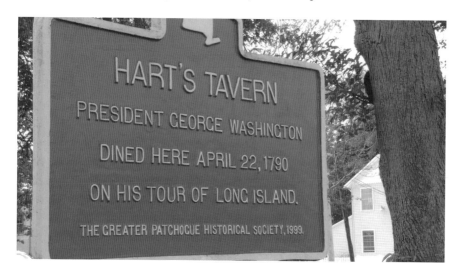

Hart's Tavern sign, Patchogue. *Author's photo.*

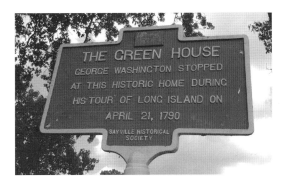

Right: Green House sign, Sayville. *Author's photo.*

Below: Green House, Sayville. *Author's photo.*

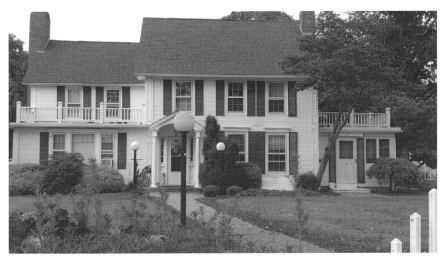

Harts Tavern was said to be "on the north side of Montauk Highway at the westerly entrance to Patchogue."[119] The tavern adjoined the Lakeview Cemetery, where a Washington Memorial Elm had been planted.[120] One account notes that Harts Tavern and the Willows, the home of Seba (a well-known author and editor) and Elizabeth Oakes Smith, are the same. This home, situated on the brow of the hill (of Lakeview Cemetery), was said to be "built and occupied for years by Revolutionary War hero General Nathaniel Woodhull of Mastic family." Washington was also said to eat oysters, a Long Island staple, prepared by local people.[121]

The taverns of Washington's time were plentiful and the only way, besides private residences, of staying somewhere and enjoying food and drink. Washington's tour of Long Island included both taverns and private residences arranged ahead of time for him. Taverns were where people met to do business, to foment the American Revolution and to rest while

continuing on a journey. Taverns were thus more than mere drinking establishments. They were often the heart of communities or cities. The City Tavern in Philadelphia was one such establishment. Michie Tavern near Jefferson's home, Monticello, in Charlottesville, Virginia, was another. Washington had often attended balls and events at Gadsby's Tavern in Alexandria, Virginia, a city that he helped survey.[122] He also often danced at Gadsby's Tavern in Alexandria; by the time he was nineteen years old, he was already a proficient dancer.[123]

New York City in that era had many taverns, including several Black Horse Taverns, Nassau Street Tavern, Queens Head–*Fraunces* Tavern and Stone Bridge Tavern. On Long Island, there was, among others, Rachel Chicester's Tavern (Mother Chick's) in Huntington and Old Roe Tavern in Setauket.[124]

Washington himself frequented many different taverns during his lifetime before, during and after the Revolutionary War. In different regions of Virginia, he went to the Harpers Ferry Tavern, Hawkins Tavern in Alexandria, Julian's Tavern in Fredericksburg, Kemp's Tavern in Culpeper and the Raleigh Tavern in Williamsburg. These taverns and many others were the mainstays of local life as he traveled leading up to April 20–24, 1790, as he toured Long Island. In New York City and on Long Island, he went to Barre's Tavern in New Utrecht, Blidenberg's Tavern in Smithtown, Hart's Tavern, Hull's Tavern, Ketcham's Tavern, Mariner's Tavern, Platt's Tavern in Huntington, Roe's Tavern in Setauket, Simmond's Tavern in South Hempstead, Thompson's Tavern, Warne's Tavern and Willet's Tavern.[125]

"After the American Revolution, George Washington's birthday came to substitute for those traditional celebrations, eventually becoming a national commemoration by 1832. In 1799, for example, George Washington recorded that he 'Went up to Alexandria to the celebration of my birthday. Many Manoeuvres were performed by the Uniform Corps and an elegant Ball & Supper at Night.' The evening events were held that year at Gadsby's Tavern on the corner of Cameron and Royal Streets."[126]

PATCHOGUE was the last stop east on the southern part of Washington's tour. As he mentioned in his diary, the soil "became more and more sandy and less productive as he travelled eastward."[127] And yet Patchogue had a unique history during the era of Washington's tour. It's Native American, Dutch and English history and maritime location combined to make it a growing area for commerce and residences. Although decimated of raw material and supplies after the Revolutionary War and British occupation, Long Island was ripe for new growth.

For commerce, the Revolutionary War brought struggles with the British overharvesting oysters in Patchogue. And Patchogue had an early mill on the Patchogue River for corn and wheat. Patchogue had been one of the areas of Long Island with a significant Native American population. The name of Patchogue is from the Algonquian language meaning "a turning place" or "where two streams separate." Native Americans had established trails, trade networks, agricultural areas and culture. Different Native American tribes were connected across Long Island and into New England and other areas.[128] By the time of the Revolutionary War and after, when Washington toured Long Island, the Native American population had diminished significantly, with two reservations later becoming permanent: Shinecock and Poospatuck. Other areas with Indian place names and corresponding English meanings include Coram ("a valley"), Mastic ("great river"), Shinnecock ("at the level land") and Rockaway ("sandy land"). Many of the thirteen Indian tribe names (including the Merricks, the Setaukets, the Matinecocks and the Manhassetts) were given to local towns.[129]

CHAPTER 5

NORTH SHORE SUFFOLK COUNTY

From Hart's we struck across the Island for the No. side passing the East end of the Brushey Plains—and Koram 8 miles—thence to Setakit 7 miles more the House of a Capt. Roe, which is tolerably dect. with obliging people in it.

The first five miles of the Road is too poor to admit Inhabitants or cultivation being a low scrubby Oak, not more than 2 feet high intermixed with small and ill thriven Pines.—Within two miles of Koram there are farms, but the land is of an indifferent quality much mixed with sand.—Koram contains but few houses—from thence to Setaket the soil improves, especially as you approach the Sound; but is far from being of the first quality—still a good deal mixed with Sand.—The road across from the So. to the No. side is level, except a small part So. of Koram, but the hills there are trifling.[130]

George Washington was a surveyor, both in occupation and in his heart and how he felt about the land. His Long Island diary entries are evidence of his scrutiny of the landscape. If compared, his perceptions of establishments, including taverns and homes, were decidedly less vivid than his writing about the land of Long Island where he traveled:

George Washington was an avid land surveyor throughout his life. As a rigorous outdoorsman, Washington was naturally suited to the challenges

presented by laying lines and charting tracts in the Virginia backcountry. Surveying was a respectable profession in eighteenth century America and held the promise of social and financial advancement. Over the course of fifty years Washington completed numerous surveys, many documenting the settlement of territory along Virginia's western frontier while others laid out the boundaries and agricultural fields of his continually expanding Mount Vernon plantation.[131]

Although Washington did not survey professionally after 1752,

he continued to utilize his surveying skills. He completed at least 50 more surveys, often for the purpose of acquiring new land for himself, defending his property boundaries, or dividing his holding into profitable farms. At one time, Washington owned nearly 70,000 acres between the Potomac and Ohio Rivers.[132]…Washington's profitable surveying career provided him with much that an ambitious white Virginian needed to make it big in the eighteen century. He gained familiarity with the colony's backcountry while developing methodical habits of mind and wilderness survival. He established a reputation for fairness, honesty, and dependability while making favorable impressions on members of the provincial elite. Washington also learned self-dependence and earned the rewards of ambition fulfilled.[133]

In Washington's young life, he gained experience from surveying all over Virginia, on the Potomac, on Long Marsh, on North River and in many other areas[134] that would give him the impetus as the first president to look at the land of Long Island and determine what it was at the time and what it could be in the future. Washington's ability to see commercial activity in a region of the country would carry him through the next seven years of his presidency.

In mentioning BRUSHEY PLAINS as Washington traveled north on Long Island, he noted passing through an area of Long Island with another plain, Hempstead Plain (historic spelling), which was also in the central part of the island. Both areas had little vegetation. Geologically, Hempstead Plain was "a vast tract of level land, commencing about 16 miles from the west end, and extending 12 miles east, with a breadth of 5 or 6 miles. To the eye, this whole tract appears as smooth and unbroken as the surface of the sea in a calm; though, as you pass over it, you meet with slight undulation; and the view of the traveler over the whole expanse is unobstructed, by tree, or shrub, or any other vegetable production," as historian Nathaniel Prime noted.[135]

Prime continued: "The brushy-plains is as familiar to the ear on Long Island as the great Hempstead Plain; and the contrast is remarkable. In some places, these wastes are diversified by a larger though unthriftily growth of oak, or pitch-pine; but in many instances, the trees are scattered and completely encompassed with the scrub-oak bushes, which seem to claim title as the original occupants of the ground. These plains, though occasionally interrupted, cover large portions of the body of the island. The land which they occupy is sometimes cleared and a crop or two of some value raised; but there is rarely sufficient soil to render it worthy of permanent cultivation."[136]

CORAM (Koram) had been the site during the Revolutionary War of the burning of three hundred tons of hay intended for the British army horses. According to Benjamin Tallmadge's memoir, "having now procured an accurate draft of Fort St. George, as delineated on a small scale on the foregoing page and also information that a large quantity of hay and forage had been collected by the enemy at Corum [Coram, Koram], from the East end of Long Island, I began urgently to importune Gen. Washington to permit me to capture the fort and destroy the magazine of forage. On the 11th of November he answered my letter, and authorized the enterprise."[137]

Isaac Smith, nicknamed "Petticoat Isaac" for escaping the British in women's clothes during the Revolutionary War, supposedly owned a home where Washington dined during his 1790 tour.[138] Then, as mentioned in his diary, Washington passed the very area where Revolutionary War activities took place; he was observing the land, with few houses, as it had been ten years earlier during the war.

As George Washington mentioned in his diary, he and his entourage went to the home of Captain Roe in Setakit (or SETAUKET), which was "tolerably dect. with obliging people in it."[139] AUSTIN ROE had been a member of the Culper Spy Ring during the Revolutionary War. "All members of the team had aliases or were identified by numbers in the dispatches. According to the code, Abraham Woodhull was Samuel Culper, or 722. Robert Townsend was Samuel Culper Jr., or 723. Caleb Brewster was 725, Benjamin Tallmadge was John Bolton, or 721, and Austin Roe was 724. Even George Washington was identified by the number 711."[140]

Austin Roe had been intricately involved in the spy ring. "Austin Roe was one of the messengers. One who can realize what he had to contend with must view with amazement the work of Austin Roe. Across the Sound General Washington had Dragoons posted, three every 15 miles apart to carry the messages to him, whilst on the Long Island Austin Roe rode the 55 miles from Setauket to New York and the same distance back, through

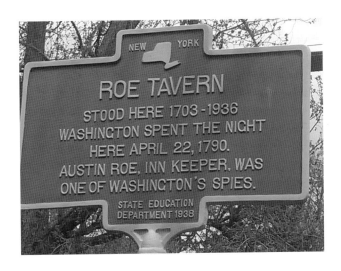

Roe Tavern, Setauket.
Author's photo.

the enemy's country, unattended. Austin Roe entered a coffee house in the vicinity of Wall St. He was visibly tired and probably hungry." His contact was Mr. Townsend, who knew that General Washington "was expecting a message." After following Townsend to his quarters, Roe was given a letter with a seemingly realistic note on one side and also a secret message from invisible ink overlapping it. Austin Roe returned to Long Island, always in the midst of danger should he be caught.[141] "He never got caught because when he was questioned by the British soldiers he would say he is getting supplies and doing business for his tavern."[142]

Then, during Washington's 1790 tour of Long Island, he traveled to the home of Austin Roe and stayed the night of April 22. "Washington's object was to survey agricultural and economic conditions on the Island, and to meet his spies there." Since "the bitterness stemming from the war gradually abated with the departure of the Tories and the Patriots in general returned to their homes from exile or from the army, there was 'excited interest' when Washington stayed in Setauket."[143]

About Washington's diary entry about Austin Roe,

> one would never suspect that Capt. Austin Roe had been an important link in the spy chain that Washington maintained on the island during the British occupation. Roe has often been called the Paul Revere of Long Island. In his [diary] entry, as everywhere else, Washington was reticent, even with his own diary. But so, for that matter was Roe; for no member of his family every knew of his activities during the War. Washington

may have planned this trip with an unexpressed objective, meeting some of the men who had formed his unofficial secret service. It is ironic that Roe, who had ridden at least 2,000 miles as a courier should, on the day of Washington's visit have fallen from his horse and sustained a broken leg so that he was unable to play host in person.[144]

Washington noted in his diary:

> Friday. 23d. About 8 o'clock we left Roe's, and baited the Horses at Smiths Town at a Widow Blidenberg's a decent House 10 miles from Setalkat—thence 15 miles to Huntington where we dined—and afterwards proceeded seven miles to Oyster-Bay, to the House of a Mr. Young (private and very neat and decent) where we lodged.—The house we dined at in Huntingdon was kept by a Widow Platt, and was tolerably good.—The whole of this days ride was over uneven ground and none of it of the first quality but intermixed in places with pebble stone.—After passing Smith-town & for near five miles it was a mere bed of white Sand, unable to produce trees 25 feet high; but a change for the better took place between that & Huntington), which is a sml. Village at the head of the Harbour of that name and continued to improve to Oyster-bay about which the Sands are good—and in the Necks between these bays are said to be fine. It is here the Lloyds own a large & valuable tract or Neck of Land from whom the British whilst they possessed New York drew large supplies of wood—and where, at present, it is said large flocks of Sheep are kept.[145]

In SMITHTOWN, the "decent house" where Washington dined belonged to the Widow Blidenberg. "Abraham Woodhull of Setauket, who was known as Samuel Culper in the spies' correspondence, reported on September 12, 1780 that the 17th Dragoons (British) had encamped in Widow Blidenbeurgh's orchard. It is not improbable that she furnished information concerning the strength of these troops, and that she may have been one of Woodhull's regular informants."[146]

The minutemen company that was raised in Smithtown took part in the Battle of Long Island in August 1776. The British occupied Smithtown after this battle, and even though there was an oath of loyalty taken by many who did not flee to Connecticut, there was much cruel treatment exacted by the

Left: Blidenberg Memorial rock sign, Smithtown. *Author's photo.*

Below: Old Burying Ground, Huntington. *Author's photo.*

British nonetheless.[147] Washington rode through this area only a few years after occupation. "Smithtown, when the war for independence began, had a population of 555 whites and 16 negroes. Town meetings had been held at least from 1715. And, nowhere on Long Island was there to be found a greater proportion of patriots. In fact, when the time came for men to declare themselves, only fifteen Loyalists were to be found in the town."[148]

"The only structures that President Washington would have seen in Smithtown Branch in 1790 would have been the Widow Blidenburgh's Tavern, the little Presbyterian meetinghouse and the Epenetus Smith Tavern. The other homes that existed in 1790 were further to the east along Middle Country Road, and since George Washington never travelled in this direction, he never saw them."[149]

HUNTINGTON for George Washington was a pleasant experience. During the Revolutionary War occupation, Huntington was a focus of British activities. An encampment in the Old Burying Ground called Fort Golgotha contributed to a desecration of this cemetery and churches in the area. The people of Huntington had resisted in 1774 prior to the Battle of Long Island with a "Declaration of Rights." Washington wrote in his diary of the meal at the Widow Platt's, as well as of the Lloyd family on one of the necks of land, situated in the north of Huntington.

During the occupation of Long Island and Lloyd Manor, the Lloyd family was not in residence, and as Washington noted in his diary, the British took

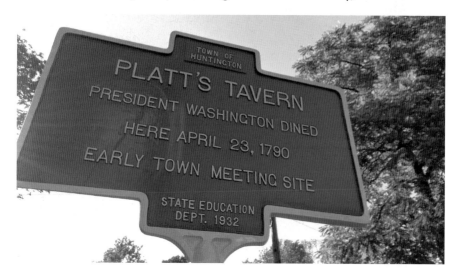

Platts Tavern sign, Huntington. *Author's photo.*

Joseph Lloyd Manor sign, Lloyd Neck. *Author's photo.*

Joseph Lloyd Manor, Lloyd's Neck. *Author's photo.*

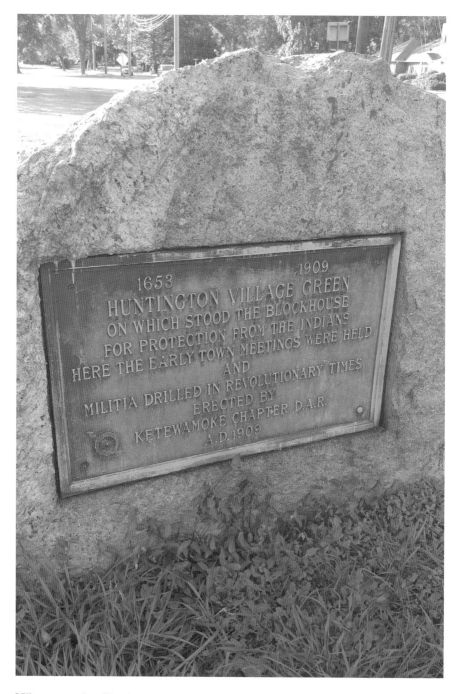

Village green sign, Huntington. *Author's photo.*

large amounts of wood. The British apparently "cut at least three-quarters of Joseph and John Lloyd's wood for the use of the army. Upward of 800 Loyalists were stationed on the Neck as defenders and woodcutters. Probably some were quartered in the mansion built by Joseph Lloyd, without doubt the most imposing house on the manor."[150]

The aftermath of occupation proved beneficial for some Lloyds and not beneficial for others. As with many Loyalist properties that were confiscated by the Americans after the war, Henry Lloyd II petitioned the Royal Commission in London for "compensation for wood and damages, but received [only] 5,834 [pounds]—much less than he anticipated."[151]

Huntington during Washington's tour contained several properties and sites worthy of note. The Village Green, which he rode past, was the "Town spot where Washington stood in 1790 and thanked the people of Huntington for the role they played in the Revolutionary War."[152] In 1775, "the Minutemen were formed and they drilled on the Village Green. Since many of the men came from distant districts of the town, it was more convenient to store their weapons at the 'arsenal' rather than carry these heavy muskets home."[153]

The Arsenal with sign, Huntington. *Author's photo.*

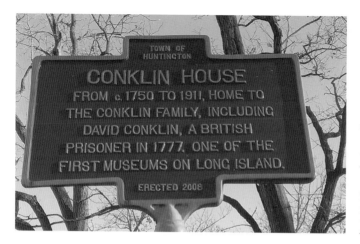

Left: Conklin House sign, Huntington. *Author's photo.*

Below: Conklin House with sign, Huntington. *Author's photo.*

Among the Huntington properties and historic residences when Washington traveled through "the small village at the head of the Harbour"[154] was the Arsenal, the home of Job Sammis. Since most people in Huntington supported the Revolution, the Town Common became the area where the initial companies of Suffolk County militia were organized. Sammis allowed for the storage of weapons and other items needed for the troops. His home was also where a large shipment of gunpowder from the New York Provincial Congress was stored and where the processing of some of the companies of militias was done. As Huntington became occupied, his home, wagon and services were forcibly used by the British.[155]

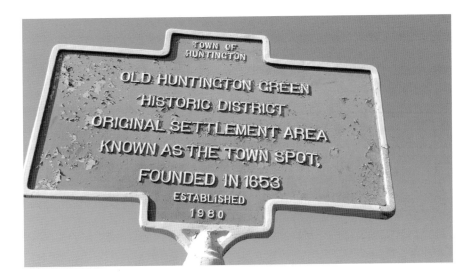

Above: Old Huntington Green sign, Huntington. *Author's photo.*

Left: Nathan Hale Memorial Rock with plaques, Halesite, Huntington. *Author's photo.*

Another historic home present when Washington traveled through Huntington was the Conklin House, with a "table and chair used by George Washington during his tour of Long Island in 1790."[156] Many areas of Huntington would become historic districts, such as the Old Town Green Historic District and Old Huntington Green Historic District.[157]

The Huntington shores are also where Nathan Hale had been captured by the British; he was transported to New York City and almost immediately hanged as a spy. His words are enshrined on a boulder in Halesite. Several sites are considered to be the spot in New York City where Hale was executed, including Sixty-Sixth Street and Third Avenue, another near the Yale Club and also downtown near city hall.

CHAPTER 6

OYSTER BAY

[A]fterwards proceeded seven miles to Oyster Bay, to the House
of a Mr. Young (private and very neat and decent) where we
lodged.[158]

O YSTER BAY was one of the unique towns that aided George Washington
during the Revolutionary War and served him after the war on his
1790 tour of Long Island.

The "Mr. Young" mentioned in Washington's diary was the British officer
Captain Daniel Young of the Royal Militia (Queens County Militia) during
the occupation of Long Island. He had inherited his house, lands and farm
on Cove Neck from his uncle. During the British occupation, there was an
overwhelming need for firewood for warmth and cooking. Long Island's
timber resources were plentiful and would be almost decimated by the
end of occupation. In addition to trees being cut down, wooden structures
like churches (including pews) were used, as well as fences and any other
structures made of wood. There was a quota system for wood and supplies
from the different areas, and Queens County was required to furnish the
incredible amount of 4,550 cords of wood.[159]

Captain Daniel Young (both "Young" and "Youngs" are noted in
historic references), "while performing his services for the Crown, was
also cooperating with the Townsends, life-long friends, at whose home in
Oyster Bay, Simcoe, Andre, and other British officers were billeted." Sally
Townsend had sent a covert message about Andre and Benedict Arnold's

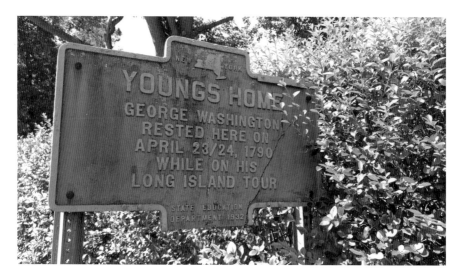

Youngs Home sign, Oyster Bay. *Author's photo.*

appointment via a need for a certain kind of tea to the shop her brother owned in New York City.[160]

Washington's visit to Oyster Bay was considered odd. "Some Long Island Tories were exiled to England and others became refugees in Canada and the West Indies after the war. But here was the new country's chief patriot general paying a social visit to a Tory's home, and being very pleasant with them all. [And as] Onderdonk reports, also took tea, called for a bowl of milk, kindly told them to 'take no particular trouble,' and stayed over night. And before he left, he gave Capt. Young's daughter, 17 year-old Keziah, a grandfatherly kiss on the check."[161]

Oyster Bay had suffered during the British occupation of Long Island. The aftermath of the war brought relief but also needed rebuilding:

Probably the people of Oyster Bay, whether Whig or Tory, felt relieved when the Revolutionary War ceased and the horrors of martial law became a thing of the past. When peace was proclaimed, industry was resumed, but the township had been so seriously drained of its resources, its fields had been so trampled on and destroyed, its granaries, when spared, had been so emptied, and its financial resources so reduced, that it took a long time to regain what had been lost during the few years of conflict. Agriculture was at that time the main industry, for the war had shattered the shipping trade, which had been promising so much prior to 1776. But the soil, not the

sea, was, after all, the mainstay of the people, and so until the nineteenth century had pretty well advanced, the story of the township might be a record of improvements in crops, in farm stock, in extension of the farm land by steady clearance of the brush and wildwood.[162]

RAYNHAM HALL in Oyster Bay was one of the seats of the Revolutionary War Culper Spy Ring, which gave George Washington spying information on Long Island. Activity and personalities regularly passed through the doors of this home. "The Townsends middle son Robert, under cover of running the family's business in Manhattan and contributing to the Loyalists broadsheet 'Rivington's Gazette,' became one of General Washington's most trusted sources of intelligence during the War. As a member of the so-called Culper Spy Ring, he transmitted vital information from British-occupied Manhattan to Gen. Washington via other agents in Oyster Bay, Setauket, and Fairfield, CT."[163]

Raynham Hall was originally built by Samuel Townsend circa 1740 and was named after another earlier Townsend home in England. He called it

Earle Wightman House, Oyster Bay. *Author's photo.*

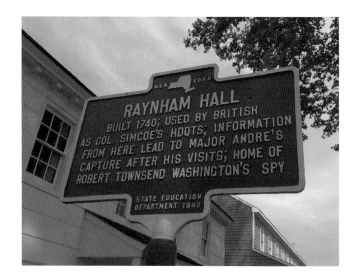

Right: Raynham Hall sign, Oyster Bay. *Author's photo.*

Below: Raynham Hall, Oyster Bay. *Author's photo.*

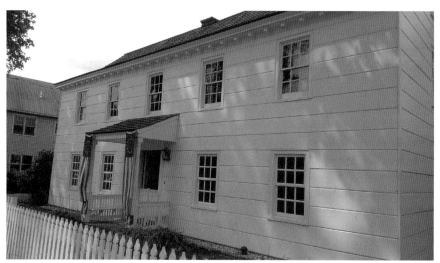

Little Raynham. Some notable British officers quartered at Raynham Hall included Colonel John Graves Simcoe of the Queens Rangers and Major John Andre.[164] "COLONEL SIMCOE, who was quartered in the Townsend house, was a 'higher up' in the plot to capture West Point and make a prisoner of Washington. Simcoe was a forceful character, and during the Revolutionary War he was the unquestioned boss of Oyster Bay. An Englishman himself he commanded a regiment composed entirely of American Loyalists. They wore a green uniform with a black hat of curious shape."[165]

MAJOR JOHN ANDRE was captured under the name "John Andersen" on September 23, 1780. Andre had been captured with papers in his boots establishing his connection to Benedict Arnold, and on September 24, he wrote a letter to General George Washington disclosing his identity as Adjutant General to the British army. Benedict Arnold had already escaped from his quarters at Robinson House across from West Point by the time General Washington got there. Major Andre was escorted to Tappan, New York, to "Head Quarters." After a court of fourteen officers was convened, Major Andre was found guilty: "[T]hat Major Andre, Adjutant-General to the British Army, ought to be considered as a spy from the enemy, and that, agreeably to the law and usage of nations, it is their opinion that he ought to suffer death." He was executed on October 2, 1780.[166]

Andre apparently visited the Townsends at Raynham Hall before his execution in 1780. Some letters found connect Andre to Oyster Bay and to Colonel Simcoe of the Queens Rangers, who billeted at Raynham Hall and used it as his headquarters from November 1778 to May 1779.[167]

The prospect of including slaves in the Patriot ranks was a possibility during the American Revolutionary War. "New York offered freedom to slaves in return for three years of military service, with a compensatory land bounty to be paid to their owners."[168] Many Long Island towns had homes with slaves included in the 1790 census, as did the Townsend family of Raynham Hall in Oyster Bay. In addition to numerous documented slaves being owned by the Townsends, a Bible printed in 1771 lists the birth and names of seventeen slaves up until the year that Washington came to tour Long Island in 1790. Even though the Townsends owned slaves, they did not wholeheartedly support the institution. However, as early as 1749, the Townsends bought a slave, and by the time Samuel Townsend died in 1790, the year of Washington's visit, he had three slaves.[169]

In Suffolk County in Smithtown, "The census of June 1776, just one month before the formal Colonial Declaration of Independence, showed a total population in Smithtown of 716 persons, 161 of whom were of African descent. It is not indicated in the census how many African Americans were free, and how many were slaves."[170]

CHAPTER 7

ROSLYN

Saturday, April 24th. Left Mr. Young's before 6 o'clock and passing Musqueto Cove, breakfasted at a Mr. Underdunck's at the head of a little bay; where we were kindly received and well entertained.—This Gentleman works a Grist & two Paper Mills, the last of which he seems to carry on with spirit, and to profit—distc. From Oyster Bay 12 miles.[171]

MUSQUETO COVE, eventually to be called GLEN COVE, was one of the towns that exhibited great celebration after Revolutionary occupation. There had been great animosity after the war, from the Patriots to the Loyalists, because of the very poor treatment suffered by the Patriots at the hands of the British and the Loyalists. When more than two hundred ships filled with Loyalists departed for Halifax, Nova Scotia, between July and October 1783, there was great joy felt. The farms of Thomas Butler at Dosoris and Rem Hegenan at Cedar Swamp both hosted celebrations. Turkeys, geese and ducks were in abundance as food at Butler's farm, while the Hegenan farm honored Colonel John Sands (in whose militia unit some from Musqueto Cove served).[172]

During the American Revolution, the population of Musqueto Cove was estimated at about 250. Glen Cove had a quality harbor for ships, and it was a gathering point for firewood, which would be shipped to New York City for the British troops. Both British and Hessians had been stationed in the area. The Patriot names of Coles, Townsend, Carpenter, Craft and Hopkins

were deeply involved in the occupation struggle on Long Island.[173] Oyster Bay, Glen Cove and Roslyn would become part of the beginnings of the new Nassau County, which split from Queens County. There had been great Revolutionary division in Queens County, which had originally encompassed these towns as well as the more southern shore area of Hempstead all the way to Suffolk County.

After the October 1776 Loyalist address to Governor Tryon, "The eastern towns of Queens split geographically over the Revolution with the northern necks definitely in support of the Revolutionary cause. There had been a long standing difference between the northern and southern areas caused by animosity over land rights, and from the fact that the largely mercantile, leadership of the millers and merchants on the north shore felt a close affinity to the Revolutionary interest in New England."[174]

The occupation lasted until 1783. "In March of 1784, Benjamin Ackley and other inhabitants of North Hempstead petitioned the Legislature for a division of the Town of Hempstead. On April 6, 1784 it passed the Legislature providing [that] '[a]ll that part of said township of Hempstead north of the county road that leads from Jamaica nearly through the middle of Hempstead Plain to the east part thereof, shall be included in one township; and be hereafter called and known by North Hempstead. The remaining part was called South Hempstead but subsequently the name was changed back to Hempstead in 1801,'" as historian Edward J. Smits noted.[175] "As we have seen originally a part of the town of Hempstead but was organized as a separate town by act of April 6, 1784, entitled 'An Act for Dividing the Town of Hempstead into Two Towns.' The first town meeting in this town after its separation was held at the house of Samuel Searing in the village of Searing Town, April 14, 1784, when John Schenck, Esq. was re-elected clerk."[176]

During the war, "the Patriot Communities of Great Neck, Manhasset and Roslyn seceded and formed the Town of North Hempstead."[177]

During Washington's visit to ROSLYN, he wrote in his diary about visiting the "Underdunck" home and saw that he had a gristmill and two paper mills. Washington had his own gristmill built in 1771 at his home in Mount Vernon, Virginia. His mill had inventive, forward-looking technology. It fed the enslaved population and had slave and hired labor. As a very profitable enterprise, it exported wheat.[178]

Washington described in his diary of the work at the "Grist and two Paper Mills" as being carried on "with spirit and profit." "The 1773 Paper Mill was established by Hendrick Onderdonk. It was the first paper mill

in New York State and one of the first in the Colonies. Paper manufacturing had been suppressed in the Colonial era and import duties were high."[179] Paper was at first made from rags, and papermaking was a very profitable business. It is believed that this mill of Onderdonk's operated throughout the Revolutionary War. By the time President George Washington visited the owner, Hendrick Onderdonck, in 1790, there were two paper mills being operated by the man.[180]

The gristmill had changed hands a few times by the time Washington had seen it. The town records of North Hempstead mentioned a road from "Robinsons Mill Dam in the early 1710s" and then "the sale of the mill by John Robinson to Charles Mott for one hundred pounds in 1709."[181] The gristmill and paper mill were across the small body of water. "The paper mill was the first such erected in the

Above: Gristmill, Roslyn. *Author's photo.*

Opposite: Paper Mill, Roslyn. *Author's photo.*

province in the mid-eighteenth century by Andrew Onderdonk. It is highly probable that, as family tradition has it, Washington made a sheet of paper, for he was interested in 'mechanick matters.' Onderdonk's paper was of the highest quality and was later used in our currency. Washington may well have wished to thank Onderdonk for his morale work during the [Revolutionary] War and for his outspoken support of the new government as soon as it was formed."[182]

"The greatest fame of the family Onderdonk arises from the visit of General Washington to their home in 1790. After spending the night at the Youngs' home in Oyster Bay, he arose early for the journey by coach to New York, and word was brought to the Onderdonks that the General would take breakfast with them. The family were already at their breakfast of fried clams when the message came. It is said that after breakfast Washington and his host walked to the Knoll behind the house, viewed the harbor, and then visited the Paper Mill."[183]

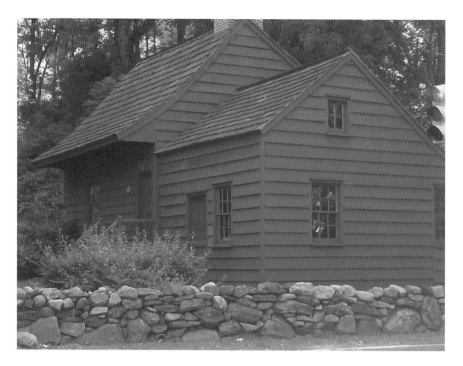

Van Nostrand–Starkins House, Roslyn. *Author's photo.*

Hendrick Onderdonk came to live in Roslyn in 1752. "He began his business career as owner of a local country store, and his political career as overseer of Highways for the Town of Hempstead. Soon Onderdonk was owner of a grist mill and bake house. In 1769 he was elected Supervisor of the Town and four years later, built a paper mill. Local legend has it at the time of the Revolution Onderdonk (a rebel sympathizer) was smuggling messages out of the mill to West Point. The messages were supposed to have been hidden between stacks of innocuous looking sheets of white paper."[184]

Another historic home that existed as Washington toured Roslyn is the 1680 VAN NOSTRAND–STARKINS HOUSE. "In 1680, colonist William Van Nostrand built a modest house in Hempstead Harbor. In 1740, the residence became the home of blacksmith Joseph Starkins."[185] In the earliest written record of this house, the "Federal census of 1790…lists William Van Nostrand as the head of the household."[186]

CHAPTER 8

NORTHERN QUEENS
(NASSAU COUNTY)

From hence to Flushing where we dined is 12 more—& from
thence to Brooklyne through Newton (the way we travelled and
which is a mile further than to pass through Jamaica) is 18 miles
more. The land I passed over to day is generally very good, but
leveler and better as we approached New York—the soil in places
is intermixed with pebble, and towards the West end with other
kind of stone, which they apply to the purposes of fencing which
is not to be seen on the South side of the Island, nor towards
the Eastern parts of it.—From Flushing to New Town 8 miles
& thence to Brooklyn, the road is very fine, and the Country
in a higher state of cultivation & vegetation of Grass & grain
forwarded than any place also, I had seen, occaisined [sic] in a
great degree by the Manure drawn from the City of New York,—
before sundown we had crossed the Ferry and was at home.[187]

As Washington traveled between Roslyn and Flushing, he passed through
the NORTHERN QUEENS COUNTY of the era, which also encompassed
Port Washington, Manhasset and Great Neck. PORT WASHINGTON retained
its charm with several historic homes, including the Sands home (later to be
called the Sands-Willet House), the Dodge Homestead and other properties.
 The SANDS HOME of the eighteenth century was

*typical of the prosperous Long Island farmhouses that grew to fit the needs
of the families who lived in them. The house, built on a peninsula known*

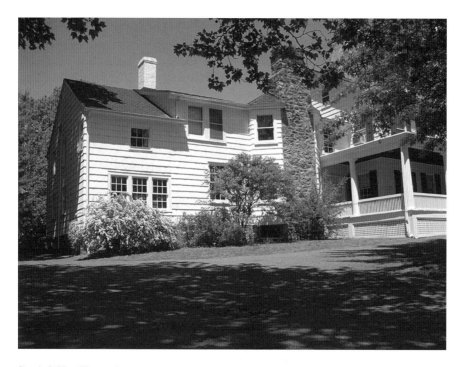

Sands-Willet House, Sands Wing, Port Washington. *Fred Blumlein, trustee, Cow Neck Peninsula Historical Society.*

in earlier times as "Cow Neck" is part of the Revolutionary War Trail of the era. The Sands family, merchant and farmers, lived in the original west of the house beginning in 1735. In the late 1600s, the Sands were among the first English families to settle on Cow Neck. Seven brothers, who were all born in the western wing of the house, served and fought in the American Revolution. One of these brothers, minuteman, Colonel John Wands IV, born in 1737, was with George Washington's army at the Battle of [Long Island, fought] *in Brooklyn Heights.*[188]

The THOMAS DODGE HOMESTEAD was residence of

Thomas Dodge (1684–1755), an original Cow Neck homesteader/ farmer, [who] *came to the peninsula from Block Island in about 1709. Between 1718 and 1730, Thomas purchased approximately 345 acres of land on Cow Neck for mostly sheep raising and farming. In 1721, Thomas built a log cabin on a hill overlooking Manhasset Bay and today's Mill Pond and then constructed a small house just north of the Dodge*

Homestead house. It is conjectured that Thomas' son, Joseph, built the oldest part of this present house around 1763. During the Revolutionary War, Hessian soldiers occupied a portion of the house called the "Weaving Room." The descendants of Thomas [continued] *to occupy the house.*[189]

Great Neck was deeply embroiled in pre–American Revolution politics. It was part of the northern part of the town of Hempstead, which was more like New England and had a concentration of Presbyterian, Congregationalist and Quaker ties. This area wanted independence from Great Britain. The 1775 vote by the seceded town of North Hempstead was finalized in 1784. There were still split loyalties within Great Neck, but in 1776, Great Neck and Cow Neck (Port Washington) supported the Continental Congress with a loyal association that noted that "[they were] greatly alarmed at the avowed design of the Ministry to raise a revenue in America."[190]

Great Neck was strategic during the Revolutionary War in affording good vantage points for patrolling the water, engaging in raids or providing intelligence information for spying. The war was a tumultuous period of succumbing to the occupation demands of British and Hessian armies. Like other areas of Long Island, livestock and supplies were taken and assaults on citizens were also carried out by Tories against Whigs. "When the war ended, this area had been laid waste and the peaceful rural life of its inhabitants had been completely disrupted."[191]

Madnan's Neck sign, Great Neck. *Author's photo.*

As George Washington toured Long Island in 1790, he passed several churches, some of which had sided with the Loyalists during the Revolutionary War and some with the Patriots; some had attempted to remain neutral. Several churches not affiliated with Britain suffered greatly during the war, used as stables or barracks or dismantled for firewood.

The OLD QUAKER MEETING HOUSE in FLUSHING was built by John Bowne and other Quakers in 1694 and is considered the "oldest house of worship in New York State and the second oldest Quaker meeting house in the nation. George Washington and William Penn both visited this Quaker Meeting House."[192] "During the Revolutionary War the Old Meeting House was used as a prison, a hospital, a barracks and as a storage place for feed. When the British officers came to take possession in 1776 religious services were being held. It is said that the officers were so impressed with the fervor of the worshipers that they waited until the services were completed before seizing the building for their use. During this period the army utilized the fence around the grounds as firewood. Many of the Friends of Flushing suffered fines from both sides during the war because they would not contribute funds for the support of the two armies. In 1783 after the close of the war, the meeting house was repaired and restored to its original use."[193]

ST. GEORGE'S CHURCH in HEMPSTEAD was affiliated with the Loyalists during the war, as most people were Loyalists in that area. "The church was closed for three Sundays before the British arrived [for occupation in September 1776]. By January 1777, Mr. Cutting (the rector) had stated in a letter that St. George's Church fared better than most churches under occupation. When the British occupied Long Island, this congregation was content. However (since) it was the only church in the area that was allowed to operate as a church, so it was particularly vulnerable to Patriot attacks."[194]

ST. JOHN'S EPISCOPAL CHURCH in OAKDALE was originally called Charlotte Church to honor George III's queen. Built in 1765, the church was already twenty-five years old by the time George Washington visited Long Island. During the Revolutionary War, the British occupied the church. Damage was still being repaired by the time Washington visited Long Island in 1790.[195] The name of the church was changed to St. John's Church after the war when the residents remembered the outrage of occupation damage and the era of independence allowed for a new direction.[196]

The CAROLINE CHURCH building in SETAUKET was from 1729 and was sixty-one years old by the time George Washington traveled through that area. Just a few years earlier, the church had been used for the wounded

St. George's Church, Hempstead. *Author's photo.*

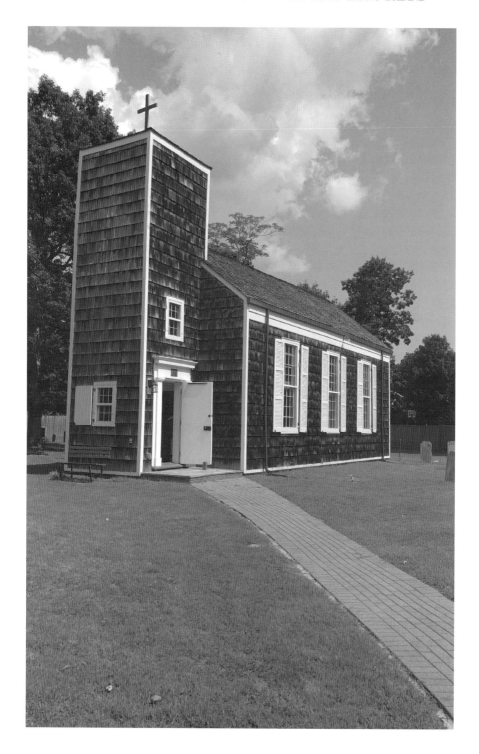

Above: St. John's Church, interior, Oakdale. *Author's photo.*

Left: St. John's Church sign, Oakdale. *Author's photo.*

Opposite: St. John's Church, Oakdale. *Author's photo.*

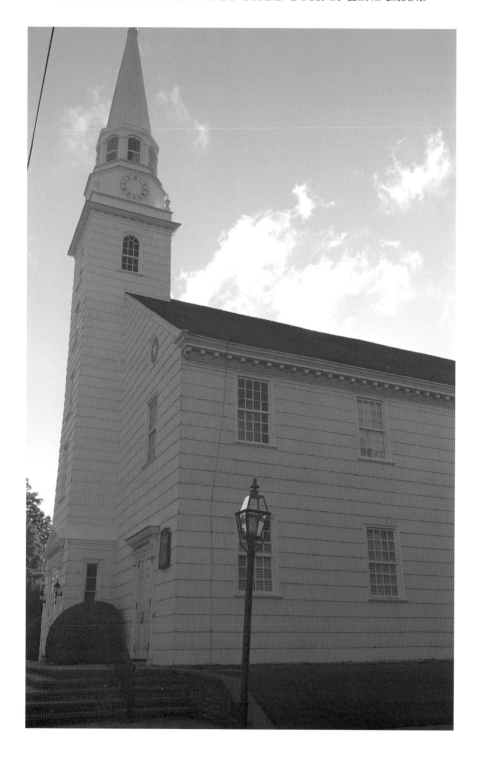

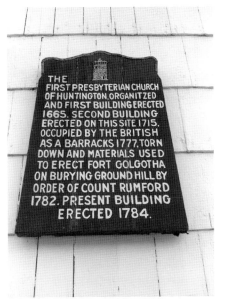
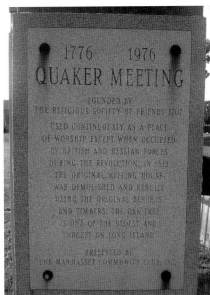

Above, left: Old First Church sign, Huntington. *Author's photo.*

Above, right: Quaker Meeting House sign, Manhasset. *Author's photo.*

Opposite: Old First Church, Huntington. *Author's photo.*

from the Battle of Setauket on August 22, 1777. The Loyalist affiliation of the original congregation was seen in honoring King George II's wife, Queen Wilhelmina Karoline, in naming the church. The January 25, 1790 vestry records stated "that this Church and parish Shall I honor of our gracious Queen, her most Serene Britannic Majesty be hereafter called Caroline Church."[197]

The Old First Church in Huntington is a historic congregation from 1653. The church building was originally constructed just west of where Washington traveled in 1790 and later moved on top of East Hill. The minister during the first part of the Revolutionary War, Ebenezer Prime, was very patriotic and supported the Revolution. Once he passed in 1779, "Col. Benjamin Thompson of the Queen's Rangers tore down the church and used the timbers to construct a fort on the old burying ground hill…. Headstones were used by the British soldiers to bake bread and the church bell was stolen by them. The church was rebuilt in 1784.[198]

The Manhasset Meeting was "occupied by Hessian Cavalrymen in 1782 for which the 'Friends' protested to the English Governor. Col. Worm was

ordered to vacate and restore the building. In 1783 it was again occupied by soldiers as a guard house and considerable damage was done to the seats and fence which had to be repaired by the Meeting, as the British and Hessians were shortly forced to withdraw from the Island."[199]

GEORGE WASHINGTON'S LEGACY ON LONG ISLAND AND THE OTHER FOUNDERS ON LONG ISLAND

Observations. This island (as far as I went) from West to East seems to be equally divided between flat, and Hilly land, the former on the South next the Seaboard, & the latter on the No. next the Sound.—The highland they say is best and most productive, but the other is the pleasantest place to work, except in wet seasons when from the levelness of them they are sometimes, (but not frequently having a considerable portion of Sand) incommoded by heavy & continual rains.—From a comparative view of their crops they may be averaged as follows.—Indian Corn 25 bushels—Wheat 15—Rye 12—Oats 15 bushels to the acre.—According to their accts. From Lands highly manured they sometimes get 50 of the first, 25 of the 2d & 3d, and more of the latter.

Their general mode of Cropping is,—first Indian Corn upon a lay, manured in the hill, half a shovel full in each hold—(some scatter the dung over the field equally)—2d. Oats & Flax—3d. Wheat with what manure they can spare from the Indian Corn land—with the Wheat, or on it, towards close of the Snows, they sow Clover from 4 to 6 lb; & a quart of Timothy Seed.—this lays from 3 to 6 years according as the grass remains, or as the condition of the ground is, for so soon as they find it beginning to bind, they plow.—Their first plowing (with the Patent, tho' they call it the Dutch plow) is well executed at the

depth of about 3 or at most 4 Inches & the sod neatly & very evenly turned.—With Oxen they plough mostly. They do no more than turn the ground in this manner for India Corn before it is planted; making the holes in which it is placed with hoes the rows being marked with the Harrows or Plough is all the cultivation it receives <u>generally</u>.—Their fences, where there is no Stone, are very indifferent; frequently of plashed trees of any & every kind which have grown by chance; but it exhibits an evidence that very good fences may be made in this manner either of white Oak or Dogwood which from this mode of treatment grows thickest, and most stubborn.—this however, would be no defence against Hogs.[200]

Some of George Washington's keenest observations about Long Island were of the land. This diary was not just an idle activity of his to pass the time as he rode in his carriage but rather meant to note the rebuilding of Long Island that was taking place. His observations were based more on his long years as a surveyor in addition to being a farmer. However, now he was surveying the land of Long Island with a Presidential eye. And his observations would be noted for posterity.

George Washington was instrumental in getting a lighthouse put near the shores of Montauk on the South Fork, which is on the farthest Eastern End of Long Island. As the new nation was growing, there was a need to protect the shores, the infrastructure, trade and growing industries. Washington foresaw the changing mercantilist environment of New York City and the ship traffic coming from Europe via the North or South Shores of Long Island. The necessity of a lighthouse at the end of Long Island was paramount, as was the one on Eaton's Neck, near Huntington. Many shipwrecks had occurred on the rocky shores of Long Island. The Long Island Sound had been a major area of maritime contention and whaleboat raids during the Revolutionary War and afterward a major point of transit for foreign and domestic shipping. Some lighthouses outside New York on the East Coast had already been built in the colonial era, such as in Boston, Massachusetts and Sandy Hook, New Jersey. The building of the Montauk Lighthouse would lead to many others around Long Island, such as at Sands Point, Port Jefferson on the North Shore, Fire Island on the South Shore and Southold on the North Fork.[201]

Thomas Jefferson and James Madison traveled to Long Island in 1791:

> *On May 21, 1791, Thomas Jefferson and James Madison embarked on a month-long journey to New England and upstate New York, the object of which was not politics, as Hamiltonians and later historians assumed, but, in Madison's words, "health, recreation and curiosity." Madison's bilious attacks and Jefferson's periodical headaches vanished in the days spent walking over Revolutionary battlefields, scrutinizing botanical novelties, and fishing on Lake George. The manuscript (of Jefferson), begins at a tavern in the Highlands section of the Hudson River above Peekskill on the day after Jefferson and Madison left New York City. Except for the postscript about a wheel and axle in Middletown, Connecticut, the manuscript is silent about the return journey through Vermont, Connecticut, and the southern coast of Long Island.*[202]

However, Jefferson also collected words in the form of a vocabulary list from the Unkechaug (Indian) Nation while on the Long Island visit in 1791. His purpose while visiting Long Island was to "converse with the natives and thus secure a written vocabulary, perhaps with the intention of comparing it with languages of the Old World."[203] He spoke with two older women at Poosepatuck in the Suffolk County town of Brookhaven on June 13, 1791. With the aid of an Indian girl who spoke English, he was able to write down 180 words of the Unkechaug dialect. Unfortunately, the trunk with two copies of these words was stolen when he was at the James River. Not finding valuables, the angry thief threw the trunk into the river. Only a few leaves of the pages were recovered by a friend of Jefferson's, and through a minor miracle a few years later, some of Jefferson's Long Island work was preserved.

Several presidents have crossed the shores into the mainland of Long Island. Theodore Roosevelt, in addition to being a Long Islander, was one of the most experienced presidents and arguably one of the best. His home in Oyster Bay, Sagamore Hill, not only served as his private residence but also was the Summer White House. Theodore Roosevelt had great respect for George Washington and included a painting of Washington in his home office.

"Almost two months before Washington began his Long Island tour, he signed legislation authorizing the first census. The 1790 census, which cost the government $44,377 tells that the United States at the time had 3,929,214 inhabitants in 13 states, and the average family size was six. New

York was the fifth largest state with 340,000 residents. New York City had 33,131 residents. Of the three counties making up the entirety of Long Island, Kings (Brooklyn) was the smallest at 4,495 people. Queens (including future Nassau County) had 16,014, and Suffolk had the greatest population at 16,440."[204]

Washington's travel on Long Island roads was well documented in his diary. He noted distance, physical appearance and the makeup of roads. "Three main roads ran down the Island. The North County Road passed from the head of one harbor to another along the north shore. The South Country Road followed the south-shore beaches and between these ran the Middle Country Road."[205]

Washington's tour covered 153 miles, and the 30-mile-per-day average was considered first rate, particularly in view of the many stops. His 1790 tour lent his Revolutionary and Presidential influence to the prestige of Long Island and allowed the populace to see that although Long Island was devastated by occupation up until seven years prior, it was greatly on the mend with a strong future.

FULL DIARY OF GEORGE WASHINGTON, APRIL 20–24, 1790

Tuesday, 20th. About 8 o'clock (having previously sent over my Servants, Horses, and Carriage,) I crossed to Brooklyn and proceeded to Flat Bush—thence to Utrich—thence to Gravesend—thence through Jamaica where we lodged at a Tavern kept by one Warne—a pretty good and decent house,—at the house of a Mr. Barre, at Utrich, we dined,—the man was obliging but little else to recommend it.—He told me that their average Crop of Oats did not exceed 15 bushls. to the acre—but of Indian Corn they commonly made from 25 to 30 and often more bushels to the acre, but this was the effect of Dung from New York (about 10 cart load to the acre)—That of Wheat they sometimes got 30 bushels and often more of Rye. The land after crossing the Hills between Brooklyn flat Bush is perfectly level, and from the latter to Utrich, Gravesend and in short all that end of the Island is a rich black loam—afterwards, between—and the Jamaica Road, it is more sandy and appears to have less strength, but is still good & productive.—The grain in general had suffered but little by the openess, and Rains of the Winter and the grass (clover &c.) appeared to be coming on well,—the Inclosures are small, & under open Post & Rail fencing.—The timber is chiefly Hiccory & Oak, mixed here and there with locust & Sasafras trees,—and in places with a good deal of Cedar.—The Road until I came within a mile or two of the Jamaica Road, called the middle road kept within sight of the Sea, but the weather was so dull & at times Rainy that we lost much of the pleasures of the ride. From Brooklyn to Flatbush is called 5 miles, thence to Utrich 6—to Gravesend 2—and from thence to Jamaica 14—in all this

day 27 miles. Before I left New York this morning, I signed Commissions, appointing Mr. Carmichael Charge des Affaires at the Court of Versailles, & Mr. Short, Charge des Affaires at the Court of Versailles which though not usually given to Diplomatic Characters of their Grades was yet made necessary in the opinion of the Secretary of State by an Act of Congress.

WEDNESDAY, 21ST. The morning being clear & pleasent we left Jamaica about eight o'clock, & pursued the Road to South Hempstead, passing along the South edge of the plain of that name-a plain said to be 14 miles in length by 3 or 4 in breadth Wiithot. a Tree or a shrub growing on it except fruit trees (which do not thrive well) at the few settlemts. thereon.—The soil of this plain is said to be thin & cold, and of course not productive, even in Grass.—We baited in South Hempstead, (10 miles from Jamaica) at the House of one Simmonds, formerly a Tavern, now of private entertainment for money.—From thence turning off to the right, we fell into the South Rd. at the distance of about five miles where we came in view of the Sea & continued to be so the remaining part of the day's ride, and as near it as the road could run, for the small bays, marshes and guts, into which the tide flows at all times rendering it impassible from the hight of it by the Easterly winds.—We dined at one Ketchum's wch. had also been a public House, but now a private one—received pay for what it furnished—this House was about 14 miles from South Hempstead & a very neat and decent one.—After dinner we proceeded to a Squire Thompson's such a House as the last, that is, one that is not public but will receive pay for every thing it furnishes in the same manner as if it was.—The Road in which I passed to day, and the Country here more mixed with sand than yesterday and the soil of inferior quality ;—yet with dung which all the Corn ground receives the land yields on an average 30 bushels to the acre often more.—Of wheat they do not grow much on acct. of the Fly but the crops of Rye are good.

THURSDAY, 22D. About 8 o'clock we left Mr. Thompson's—halted awhile at one Greens distant 11 miles and dined Harts Tavern in Brookhaven township, five miles farther. To this place we travelled on what is called the South road described yesterday, but the country through which it passed grew more and more sandy and barren as we travelled Eastward, so as to become exceedingly poor indeed, but a few miles further Eastward the lands took a different complexion we were informed.—From Hart's we struck across the Island for the No. side passing the East end of the Brushey Plains—and Koram 8 miles—thence to Setakit 7 miles more to the House

of a Capt. Roe, which is tolerably dect. with obliging people in it. The first five miles of the Road is too poor to admit In-habitants or cultivation being a low scrubby Oak, not more than 2 feet hia:h intermixed with small and ill thriven Pines.—Within two miles of Koram there are farms, but the land is of an indifferent quality much mixed with sand.—Koram contains but few houses—from thence to Setaket the soil improves, especially as you approach the Sound ; but it is far from being of the first quality—still a good deal mixed with Sand.—The road across from the So. to the No. side is level, except a small part So. of Koram, but the hills there are trifling.

FRIDAY, 23D. About 8 o'clock we left Roe's, and baited the Horses at Smiths Town at a Widow Blidenberg's a decent House 10 miles from Setalkat—thence 15 miles to Huntington where we dined—and afterwards proceeded seven miles to Oyster-Bay, to the House of a Mr. Young- (private and very neat and decent) where we lodged.—The house we dined at in Huntingdon was kept by a Widow Piatt, and was tolerably good.—The whole of this days ride was over uneven ground and none of it of the first quality but intermixed in places with pebble stone.—After passing Smiths-town & for near five miles it was a mere bed of white Sand, unable to produce trees 25 feet high; but a change for the better took place between that & Huntington, which is a sml. village at the head of the Harbour of that name and continued to improve to Oyster-bay about which the Sands are good—and in the Necks between these bays are said to be fine. It is here the Lloyds own a large & valuable tract or Neck of Land from whom the British whilst they possessed New York drew large supplies of wood—and where, at present, it is said large flocks of Sheep are kept.

SATURDAY, 24TH. Left Mr. Young's before 6 o'clock and passing Musqueto Cove, breakfasted at a Mr. Underdunck's at the head of a little bay; where we were kindly received and well entertained.—This Gentleman works a Grist & two Paper Mills, the last of which he seems to carry on with spirit, and to profit—distc. from Oyster-bay 12 miles.—From hence to Flushing where we dined is 12 more—& from thence to Brooklyne through Newton (the way we travelled and which is a mile further than to pass through Jamaica) is 18 miles more. The land I passed over to day is generally very good, but leveller and better as we approached New York—the soil in places is intermixed with pebble, and towards the West end with other kind of stone, which they apply to the purposes of fencing which is not to be seen on the South side of the Island, nor towards the Eastern parts of it.—From Flushing to New Town

8 miles & thence to Brooklyn, the Road is very fine, and the Country in a higher state of cultivation & vegetation of Grass & grain forwarded than any place also, I had seen, occaisioned in a great degree by the Manure drawn from the City of New York,—before sundown we had crossed the Ferry and was at home.

OBSERVATIONS. This Island (as far as I went) from West to East seems to be equally divided between flat, and Hilly land, the former on the South next the Seaboard, & the latter on the No. next the Sound.—The highland they say is best and most productive, but the other is the pleasantest to work, except in wet seasons when from the levelness of them they are sometimes, (but not frequently having a considerable portion of Sand) incommoded by heavy & continual rains.—From a comparative view of their crops they may be aver- aged as follows.—Indian Corn 25 bushels—Wheat 15—Rye 12—Oats 15 bushels to the acre.—According to their accts. from Lands highly manured they sometimes get 50 of the first, 25 of the 2d & 3d, and more of the latter. Their general mode of Cropping is,—first Indian Corn upon a lay, manured in the hill, half a shovel full in each hole—(some scatter the dung over the field equally)—2d. Oats & Flax—3d. Wheat with what manure they can spare from the Indian Corn land—with the Wheat, or on it, towards close of the Snows, they sow Clover from 4 to 6 lb ; & a quart of Timothy Seed.—This lays from 3 to 6 years according as the grass remains, or as the condition of the ground is, for so soon as they find it beginning to. bind, they plow.—Their first plowing (with the Patent, tho' they call it the Dutch plow) is well executed at the depth of about 3 or at most 4 Inches—the cut being 9 or 10 Inches & the sod neatly & very evenly turned.—With Oxen they plough mostly. They do no more than turn the ground in this manner for Indian Corn before it is planted; making the holes in which it is placed with hoes the rows being marked off by a stick—two or three workings afterwards with the Harrows or Plough is all the cultivation it receives generally.—Their fences, where there is no Stone, are very indifferent ; frequently of plashed trees of any & every kind which have grown by chance ; but it exhibits an evidence that very good fences may be made in this manner either of white Oak or Dogwood which from this mode of treatment grows thickest, and most stubborn.—This however, would be no defence against Hogs.

APPENDIX II

GEORGE WASHINGTON DOCUMENTS, 1789–1790

WASHINGTON'S FIRST INAUGURAL ADDRESS OF APRIL 30, 1789: A TRANSCRIPTION

[April 30, 1789]

Fellow Citizens of the Senate and the House of Representatives.

Among the vicissitudes incident to life, no event could have filled me with greater anxieties than that of which the notification was transmitted by your order, and received on the fourteenth day of the present month. On the one hand, I was summoned by my Country, whose voice I can never hear but with veneration and love, from a retreat which I had chosen with the fondest predilection, and, in my flattering hopes, with an immutable decision, as the asylum of my declining years: a retreat which was rendered every day more necessary as well as more dear to me, by the addition of habit to inclination, and of frequent interruptions in my health to the gradual waste committed on it by time. On the other hand, the magnitude and difficulty of the trust to which the voice of my Country called me, being sufficient to awaken in the wisest and most experienced of her citizens, a distrustful scrutiny into his qualifications, could not but overwhelm with dispondence, one, who, inheriting inferior endowments from nature and unpractised in the duties of civil administration, ought to be peculiarly conscious of his own deficiencies. In this conflict of emotions, all I dare aver, is, that it has

been my faithful study to collect my duty from a just appreciation of every circumstance, by which it might be affected. All I dare hope, is, that, if in executing this task I have been too much swayed by a grateful remembrance of former instances, or by an affectionate sensibility to this transcendent proof, of the confidence of my fellow-citizens; and have thence too little consulted my incapacity as well as disinclination for the weighty and untried cares before me; my error will be palliated by the motives which misled me, and its consequences be judged by my Country, with some share of the partiality in which they originated.

Such being the impressions under which I have, in obedience to the public summons, repaired to the present station; it would be peculiarly improper to omit in this first official Act, my fervent supplications to that Almighty Being who rules over the Universe, who presides in the Councils of Nations, and whose providential aids can supply every human defect, that his benediction may consecrate to the liberties and happiness of the People of the United States, a Government instituted by themselves for these essential purposes: and may enable every instrument employed in its administration to execute with success, the functions allotted to his charge. In tendering this homage to the Great Author of every public and private good I assure myself that it expresses your sentiments not less than my own; nor those of my fellow-citizens at large, less than either. No People can be bound to acknowledge and adore the invisible hand, which conducts the Affairs of men more than the People of the United States. Every step, by which they have advanced to the character of an independent nation, seems to have been distinguished by some token of providential agency. And in the important revolution just accomplished in the system of their United Government, the tranquil deliberations and voluntary consent of so many distinct communities, from which the event has resulted, cannot be compared with the means by which most Governments have been established, without some return of pious gratitude along with an humble anticipation of the future blessings which the past seem to presage. These reflections, arising out of the present crisis, have forced themselves too strongly on my mind to be suppressed. You will join with me I trust in thinking, that there are none under the influence of which, the proceedings of a new and free Government can more auspiciously commence.

By the article establishing the Executive Department, it is made the duty of the President "to recommend to your consideration, such measures as he shall judge necessary and expedient." The circumstances under which I now meet you, will acquit me from entering into that subject, farther than to refer

to the Great Constitutional Charter under which you are assembled; and which, in defining your powers, designates the objects to which your attention is to be given. It will be more consistent with those circumstances, and far more congenial with the feelings which actuate me, to substitute, in place of a recommendation of particular measures, the tribute that is due to the talents, the rectitude, and the patriotism which adorn the characters selected to devise and adopt them. In these honorable qualifications, I behold the surest pledges, that as on one side, no local prejudices, or attachments; no seperate views, nor party animosities, will misdirect the comprehensive and equal eye which ought to watch over this great assemblage of communities and interests: so, on another, that the foundations of our National policy will be laid in the pure and immutable principles of private morality; and the pre-eminence of a free Government, be exemplified by all the attributes which can win the affections of its Citizens, and command the respect of the world.

I dwell on this prospect with every satisfaction which an ardent love for my Country can inspire: since there is no truth more thoroughly established, than that there exists in the economy and course of nature, an indissoluble union between virtue and happiness, between duty and advantage, between the genuine maxims of an honest and magnanimous policy, and the solid rewards of public prosperity and felicity: Since we ought to be no less persuaded that the propitious smiles of Heaven, can never be expected on a nation that disregards the eternal rules of order and right, which Heaven itself has ordained: And since the preservation of the sacred fire of liberty, and the destiny of the Republican model of Government, are justly considered as deeply, perhaps as finally staked, on the experiment entrusted to the hands of the American people.

Besides the ordinary objects submitted to your care, it will remain with your judgment to decide, how far an exercise of the occasional power delegated by the Fifth article of the Constitution is rendered expedient at the present juncture by the nature of objections which have been urged against the System, or by the degree of inquietude which has given birth to them. Instead of undertaking particular recommendations on this subject, in which I could be guided by no lights derived from official opportunities, I shall again give way to my entire confidence in your discernment and pursuit of the public good: For I assure myself that whilst you carefully avoid every alteration which might endanger the benefits of an United and effective Government, or which ought to await the future lessons of experience; a reverence for the characteristic rights of freemen, and a regard for the public harmony, will sufficiently influence your deliberations on the question how

far the former can be more impregnably fortified, or the latter be safely and advantageously promoted.

To the preceeding observations I have one to add, which will be most properly addressed to the House of Representatives. It concerns myself, and will therefore be as brief as possible. When I was first honoured with a call into the Service of my Country, then on the eve of an arduous struggle for its liberties, the light in which I contemplated my duty required that I should renounce every pecuniary compensation. From this resolution I have in no instance departed. And being still under the impressions which produced it, I must decline as inapplicable to myself, any share in the personal emoluments, which may be indispensably included in a permanent provision for the Executive Department; and must accordingly pray that the pecuniary estimates for the Station in which I am placed, may, during my continuance in it, be limited to such actual expenditures as the public good may be thought to require.

Having thus imported to you my sentiments, as they have been awakened by the occasion which brings us together, I shall take my present leave; but not without resorting once more to the benign parent of the human race, in humble supplication that since he has been pleased to favour the American people, with opportunities for deliberating in perfect tranquility, and dispositions for deciding with unparellelled unanimity on a form of Government, for the security of their Union, and the advancement of their happiness; so his divine blessing may be equally *conspicuous* in the enlarged views, the temperate consultations, and the wise measures on which the success of this Government must depend.

GEORGE WASHINGTON'S FIRST STATE OF THE UNION ADDRESS, JANUARY 8, 1790

FROM GEORGE WASHINGTON TO THE UNITED STATES SENATE AND HOUSE OF REPRESENTATIVES, 8 JANUARY 1790
TO THE UNITED STATES SENATE AND HOUSE OF REPRESENTATIVES
UNITED STATES [NEW YORK] JANUARY 8TH 1790

Fellow Citizens of the Senate, and House of Representatives.
I embrace with great satisfaction the opportunity, which now presents itself, of congratulating you on the present favourable prospects of our public

affairs. The recent accession of the important State of North Carolina to the Constitution of the United States (of which official information has been recieved)—the rising credit and respectability of our Country—the general and increasing good will towards the Government of the Union—and the concord, peace and plenty, with which we are blessed, are circumstances, auspicious, in an eminent degree to our national prosperity.

In resuming your consultations for the general good, you cannot but derive encouragement from the reflection, that the measures of the last Session have been as satisfactory to your Constituents, as the novelty and difficulty of the work allowed you to hope. Still further to realize their expectations, and to secure the blessings which a Gracious Providence has placed within our reach, will in the course of the present important Session, call for the cool and deliberate exertion of your patriotism, firmness and wisdom.

Among the many interesting objects, which will engage your attention, that of providing for the common defence will merit particular regard. To be prepared for war is one of the most effectual means of preserving peace.

A free people ought not only to be armed but disciplined; to which end a Uniform and well digested plan is requisite: And their safety and interest require that they should promote such manufactories, as tend to render them independent on others, for essential, particularly for military supplies.

The proper establishment of the Troops which may be deemed indispensible, will be entitled to mature consideration. In the arrangements which may be made respecting it, it will be of importance to conciliate the comfortable support of the Officers and Soldiers with a due regard to œconomy.

There was reason to hope, that the pacific measures adopted with regard to certain hostile tribes of Indians would have relieved the inhabitants of our Southern and Western frontiers from their depredations. But you will percieve, from the information contained in the papers, which I shall direct to be laid before you (comprehending a communication from the Commonwealth of Virginia) that we ought to be prepared to afford protection to those parts of the Union; and, if necessary, to punish aggressors.

The interests of the United States require, that our intercourse with other nations should be facilitated by such provisions as will enable me to fulfil my duty in that respect, in the manner, which circumstances may render most conducive to the public good: And to this end, that the compensations to be made to the persons, who may be employed, should, according to the nature of their appointments, be defined by law; and a competent fund designated for defraying the expenses incident to the conduct of foreign affairs.

Various considerations also render it expedient, that the terms on which foreigners may be admitted to the rights of Citizens, should be speedily ascertained by a uniform rule of naturalization.

Uniformity in the Currency, Weights and Measures of the United States is an object of great importance, and will, I am persuaded, be duly attended to.

The advancement of Agriculture, commerce and Manufactures, by all proper means, will not, I trust, need recommendation. But I cannot forbear intimating to you the expediency of giving effectual encouragement as well to the introduction of new and useful inventions from abroad, as to the exertions of skill and genius in producing them at home; and of facilitating the intercourse between the distant parts of our Country by a due attention to the Post-Office and Post Roads.

Nor am I less pursuaded, that you will agree with me in opinion, that there is nothing, which can better deserve your patrionage, than the promotion of Science and Literature. Knowledge is in every Country the surest basis of public happiness. In one, in which the measures of Government recieve their impression so immediately from the sense of the Community as in our's, it is proportionably essential. To the security of a free Constitution it contributes in various ways: By convincing those, who are entrusted with the public administration, that every valuable end of Government is best answered by the enlightened confidence of the people: And by teaching the people themselves to know and to value their own rights; to discern and provide against invasions of them; to distinguish between oppression and the necessary exercise of lawful authority; between burthens proceeding from a disregard to their convenience and those resulting from the inevitable exigencies of Society; to discriminate the spirit of liberty from that of licentiousness, cherishing the first, avoiding the last, and uniting a speedy, but temperate vigilence against encroachments, with an inviolable respect to the laws.

Whether this desirable object will be best promoted by affording aids to Seminaries of Learning already established—by the institution of a national University—or by any other expedients, will be well worthy of a place in the deliberations of the Legislature.

Gentlemen of the House of Representatives.

I saw with peculiar pleasure, at the close of the last Session, the resolution entered into by you expressive of your opinion, that an adequate provision for the support of the public Credit is a matter of high importance to the

national honor and prosperity. In this sentiment, I entirely concur. And to a perfect confidence in your best endeavours to divise such a provision, as will be truly consistent with the end, I add an equal reliance on the chearful co-operation of the othe[r] branch of the Legislature. It would be superfluous to specify inducements to a measure in which the character and permanent interests of the United States are so obviously and so deeply concerned; and which has recieved so explicit a sanction from your declaration.

Gentlemen of the Senate and House of Representatives.

I have directed the proper Officers to lay before you respectively such papers and estimates as regard the affairs particularly recommended to your consideration, and necessary to convey to you that information of the state of the Union, which it is my duty to afford.

The welfare of our Country is the great object to which our cares and efforts ought to be directed. And I shall derive great satisfaction from a co-operation with you, in the pleasing though arduous task of ensuring to our fellow Citizens the blessings, which they have a right to expect, from a free, efficient and equal Government.

GO: WASHINGTON

NATIONAL DOCUMENTS, 1789–1790

THE CONSTITUTION OF THE UNITED STATES

The following text is a transcription of the Constitution as it was penned by Jacob Shallus (1750–1796) on parchment (the document on display in the Rotunda at the National Archives Museum). The spelling and punctuation reflect the original.

WE THE PEOPLE of the United States, in Order to form a more perfect Union, establish Justice, insure domestic Tranquility, provide for the common defence, promote the general Welfare, and secure the Blessings of Liberty to ourselves and our Posterity, do ordain and establish this Constitution for the United States of America.

ARTICLE. I.

Section. 1. All legislative Powers herein granted shall be vested in a Congress of the United States, which shall consist of a Senate and House of Representatives.

Section. 2. The House of Representatives shall be composed of Members chosen every second Year by the People of the several States, and the Electors in each State shall have the Qualifications requisite for Electors of the most numerous Branch of the State Legislature.

No Person shall be a Representative who shall not have attained to the Age of twenty five Years, and been seven Years a Citizen of the United States, and who shall not, when elected, be an Inhabitant of that State in which he shall be chosen.

Representatives and direct Taxes shall be apportioned among the several States which may be included within this Union, according to their respective Numbers, which shall be determined by adding to the whole Number of free Persons, including those bound to Service for a Term of Years, and excluding Indians not taxed, three fifths of all other Persons. The actual Enumeration shall be made within three Years after the first Meeting of the Congress of the United States, and within every subsequent Term of ten Years, in such Manner as they shall by Law direct. The Number of Representatives shall not exceed one for every thirty Thousand, but each State shall have at Least one Representative; and until such enumeration shall be made, the State of New Hampshire shall be entitled to chuse three, Massachusetts eight, Rhode-Island and Providence Plantations one, Connecticut five, New-York six, New Jersey four, Pennsylvania eight, Delaware one, Maryland six, Virginia ten, North Carolina five, South Carolina five, and Georgia three.

When vacancies happen in the Representation from any State, the Executive Authority thereof shall issue Writs of Election to fill such Vacancies.

The House of Representatives shall chuse their Speaker and other Officers; and shall have the sole Power of Impeachment.

Section. 3. The Senate of the United States shall be composed of two Senators from each State, chosen by the Legislature thereof, for six Years; and each Senator shall have one Vote.

Immediately after they shall be assembled in Consequence of the first Election, they shall be divided as equally as may be into three Classes. The Seats of the Senators of the first Class shall be vacated at the Expiration of the second Year, of the second Class at the Expiration of the fourth Year, and of the third Class at the Expiration of the sixth Year, so that one third may be chosen every second Year; and if Vacancies happen by Resignation, or otherwise, during the Recess of the Legislature of any State, the Executive thereof may make temporary Appointments until the next Meeting of the Legislature, which shall then fill such Vacancies.

No Person shall be a Senator who shall not have attained to the Age of thirty Years, and been nine Years a Citizen of the United States, and who

shall not, when elected, be an Inhabitant of that State for which he shall be chosen.

The Vice President of the United States shall be President of the Senate, but shall have no Vote, unless they be equally divided.

The Senate shall chuse their other Officers, and also a President pro tempore, in the Absence of the Vice President, or when he shall exercise the Office of President of the United States.

The Senate shall have the sole Power to try all Impeachments. When sitting for that Purpose, they shall be on Oath or Affirmation. When the President of the United States is tried, the Chief Justice shall preside: And no Person shall be convicted without the Concurrence of two thirds of the Members present.

Judgment in Cases of Impeachment shall not extend further than to removal from Office, and disqualification to hold and enjoy any Office of honor, Trust or Profit under the United States: but the Party convicted shall nevertheless be liable and subject to Indictment, Trial, Judgment and Punishment, according to Law.

Section. 4. The Times, Places and Manner of holding Elections for Senators and Representatives, shall be prescribed in each State by the Legislature thereof; but the Congress may at any time by Law make or alter such Regulations, except as to the Places of chusing Senators.

The Congress shall assemble at least once in every Year, and such Meeting shall be on the first Monday in December, unless they shall by Law appoint a different Day.

Section. 5. Each House shall be the Judge of the Elections, Returns and Qualifications of its own Members, and a Majority of each shall constitute a Quorum to do Business; but a smaller Number may adjourn from day to day, and may be authorized to compel the Attendance of absent Members, in such Manner, and under such Penalties as each House may provide.

Each House may determine the Rules of its Proceedings, punish its Members for disorderly Behaviour, and, with the Concurrence of two thirds, expel a Member.

Each House shall keep a Journal of its Proceedings, and from time to time publish the same, excepting such Parts as may in their Judgment require Secrecy; and the Yeas and Nays of the Members of either House on any question shall, at the Desire of one fifth of those Present, be entered on the Journal.

Neither House, during the Session of Congress, shall, without the Consent of the other, adjourn for more than three days, nor to any other Place than that in which the two Houses shall be sitting.

Section. 6. The Senators and Representatives shall receive a Compensation for their Services, to be ascertained by Law, and paid out of the Treasury of the United States. They shall in all Cases, except Treason, Felony and Breach of the Peace, be privileged from Arrest during their Attendance at the Session of their respective Houses, and in going to and returning from the same; and for any Speech or Debate in either House, they shall not be questioned in any other Place.

No Senator or Representative shall, during the Time for which he was elected, be appointed to any civil Office under the Authority of the United States, which shall have been created, or the Emoluments whereof shall have been encreased during such time; and no Person holding any Office under the United States, shall be a Member of either House during his Continuance in Office.

Section. 7. All Bills for raising Revenue shall originate in the House of Representatives; but the Senate may propose or concur with Amendments as on other Bills.

Every Bill which shall have passed the House of Representatives and the Senate, shall, before it become a Law, be presented to the President of the United States; If he approve he shall sign it, but if not he shall return it, with his Objections to that House in which it shall have originated, who shall enter the Objections at large on their Journal, and proceed to reconsider it. If after such Reconsideration two thirds of that House shall agree to pass the Bill, it shall be sent, together with the Objections, to the other House, by which it shall likewise be reconsidered, and if approved by two thirds of that House, it shall become a Law. But in all such Cases the Votes of both Houses shall be determined by yeas and Nays, and the Names of the Persons voting for and against the Bill shall be entered on the Journal of each House respectively. If any Bill shall not be returned by the President within ten Days (Sundays excepted) after it shall have been presented to him, the Same shall be a Law, in like Manner as if he had signed it, unless the Congress by their Adjournment prevent its Return, in which Case it shall not be a Law.

Every Order, Resolution, or Vote to which the Concurrence of the Senate and House of Representatives may be necessary (except on a question of Adjournment) shall be presented to the President of the United States;

and before the Same shall take Effect, shall be approved by him, or being disapproved by him, shall be repassed by two thirds of the Senate and House of Representatives, according to the Rules and Limitations prescribed in the Case of a Bill.

Section. 8. The Congress shall have Power to lay and collect Taxes, Duties, Imposts and Excises, to pay the Debts and provide for the common Defence and general Welfare of the United States; but all Duties, Imposts and Excises shall be uniform throughout the United States;

To borrow Money on the credit of the United States;

To regulate Commerce with foreign Nations, and among the several States, and with the Indian Tribes;

To establish an uniform Rule of Naturalization, and uniform Laws on the subject of Bankruptcies throughout the United States;

To coin Money, regulate the Value thereof, and of foreign Coin, and fix the Standard of Weights and Measures;

To provide for the Punishment of counterfeiting the Securities and current Coin of the United States;

To establish Post Offices and post Roads;

To promote the Progress of Science and useful Arts, by securing for limited Times to Authors and Inventors the exclusive Right to their respective Writings and Discoveries;

To constitute Tribunals inferior to the supreme Court;

To define and punish Piracies and Felonies committed on the high Seas, and Offences against the Law of Nations;

To declare War, grant Letters of Marque and Reprisal, and make Rules concerning Captures on Land and Water;

To raise and support Armies, but no Appropriation of Money to that Use shall be for a longer Term than two Years;

To provide and maintain a Navy;

To make Rules for the Government and Regulation of the land and naval Forces;

To provide for calling forth the Militia to execute the Laws of the Union, suppress Insurrections and repel Invasions;

To provide for organizing, arming, and disciplining, the Militia, and for governing such Part of them as may be employed in the Service of the United States, reserving to the States respectively, the Appointment of the Officers, and the Authority of training the Militia according to the discipline prescribed by Congress;

To exercise exclusive Legislation in all Cases whatsoever, over such District (not exceeding ten Miles square) as may, by Cession of particular States, and the Acceptance of Congress, become the Seat of the Government of the United States, and to exercise like Authority over all Places purchased by the Consent of the Legislature of the State in which the Same shall be, for the Erection of Forts, Magazines, Arsenals, dock-Yards, and other needful Buildings;—And

To make all Laws which shall be necessary and proper for carrying into Execution the foregoing Powers, and all other Powers vested by this Constitution in the Government of the United States, or in any Department or Officer thereof.

Section. 9. The Migration or Importation of such Persons as any of the States now existing shall think proper to admit, shall not be prohibited by the Congress prior to the Year one thousand eight hundred and eight, but a Tax or duty may be imposed on such Importation, not exceeding ten dollars for each Person.

The Privilege of the Writ of Habeas Corpus shall not be suspended, unless when in Cases of Rebellion or Invasion the public Safety may require it.

No Bill of Attainder or ex post facto Law shall be passed.

No Capitation, or other direct, Tax shall be laid, unless in Proportion to the Census or enumeration herein before directed to be taken.

No Tax or Duty shall be laid on Articles exported from any State.

No Preference shall be given by any Regulation of Commerce or Revenue to the Ports of one State over those of another: nor shall Vessels bound to, or from, one State, be obliged to enter, clear, or pay Duties in another.

No Money shall be drawn from the Treasury, but in Consequence of Appropriations made by Law; and a regular Statement and Account of the Receipts and Expenditures of all public Money shall be published from time to time.

No Title of Nobility shall be granted by the United States: And no Person holding any Office of Profit or Trust under them, shall, without the Consent of the Congress, accept of any present, Emolument, Office, or Title, of any kind whatever, from any King, Prince, or foreign State.

Section. 10. No State shall enter into any Treaty, Alliance, or Confederation; grant Letters of Marque and Reprisal; coin Money; emit Bills of Credit; make any Thing but gold and silver Coin a Tender in Payment of Debts; pass any Bill of Attainder, ex post facto Law, or Law impairing the Obligation of Contracts, or grant any Title of Nobility.

No State shall, without the Consent of the Congress, lay any Imposts or Duties on Imports or Exports, except what may be absolutely necessary for executing it's inspection Laws: and the net Produce of all Duties and Imposts, laid by any State on Imports or Exports, shall be for the Use of the Treasury of the United States; and all such Laws shall be subject to the Revision and Controul of the Congress.

No State shall, without the Consent of Congress, lay any Duty of Tonnage, keep Troops, or Ships of War in time of Peace, enter into any Agreement or Compact with another State, or with a foreign Power, or engage in War, unless actually invaded, or in such imminent Danger as will not admit of delay.

ARTICLE. II.

Section. 1. The executive Power shall be vested in a President of the United States of America. He shall hold his Office during the Term of four Years, and, together with the Vice President, chosen for the same Term, be elected, as follows.

Each State shall appoint, in such Manner as the Legislature thereof may direct, a Number of Electors, equal to the whole Number of Senators and Representatives to which the State may be entitled in the Congress: but no Senator or Representative, or Person holding an Office of Trust or Profit under the United States, shall be appointed an Elector.

The Electors shall meet in their respective States, and vote by Ballot for two Persons, of whom one at least shall not be an Inhabitant of the same State with themselves. And they shall make a List of all the Persons voted for, and of the Number of Votes for each; which List they shall sign and certify, and transmit sealed to the Seat of the Government of the United States, directed to the President of the Senate. The President of the Senate shall, in the Presence of the Senate and House of Representatives, open all the Certificates, and the Votes shall then be counted. The Person having the greatest Number of Votes shall be the President, if such Number be a Majority of the whole Number of Electors appointed; and if there be more than one who have such Majority, and have an equal Number of Votes, then the House of Representatives shall immediately chuse by Ballot one of them for President; and if no Person have a Majority, then from the five highest on the List the said House shall in like Manner chuse the President. But in chusing the President, the Votes shall be taken by States, the Representation from each State having one Vote; A quorum for this Purpose shall consist of a Member or Members from two

thirds of the States, and a Majority of all the States shall be necessary to a Choice. In every Case, after the Choice of the President, the Person having the greatest Number of Votes of the Electors shall be the Vice President. But if there should remain two or more who have equal Votes, the Senate shall chuse from them by Ballot the Vice President.

The Congress may determine the Time of chusing the Electors, and the Day on which they shall give their Votes; which Day shall be the same throughout the United States.

No Person except a natural born Citizen, or a Citizen of the United States, at the time of the Adoption of this Constitution, shall be eligible to the Office of President; neither shall any Person be eligible to that Office who shall not have attained to the Age of thirty five Years, and been fourteen Years a Resident within the United States.

In Case of the Removal of the President from Office, or of his Death, Resignation, or Inability to discharge the Powers and Duties of the said Office, the Same shall devolve on the Vice President, and the Congress may by Law provide for the Case of Removal, Death, Resignation or Inability, both of the President and Vice President, declaring what Officer shall then act as President, and such Officer shall act accordingly, until the Disability be removed, or a President shall be elected.

The President shall, at stated Times, receive for his Services, a Compensation, which shall neither be encreased nor diminished during the Period for which he shall have been elected, and he shall not receive within that Period any other Emolument from the United States, or any of them.

Before he enter on the Execution of his Office, he shall take the following Oath or Affirmation:—"I do solemnly swear (or affirm) that I will faithfully execute the Office of President of the United States, and will to the best of my Ability, preserve, protect and defend the Constitution of the United States."

Section. 2. The President shall be Commander in Chief of the Army and Navy of the United States, and of the Militia of the several States, when called into the actual Service of the United States; he may require the Opinion, in writing, of the principal Officer in each of the executive Departments, upon any Subject relating to the Duties of their respective Offices, and he shall have Power to grant Reprieves and Pardons for Offences against the United States, except in Cases of Impeachment.

He shall have Power, by and with the Advice and Consent of the Senate, to make Treaties, provided two thirds of the Senators present concur; and

he shall nominate, and by and with the Advice and Consent of the Senate, shall appoint Ambassadors, other public Ministers and Consuls, Judges of the supreme Court, and all other Officers of the United States, whose Appointments are not herein otherwise provided for, and which shall be established by Law: but the Congress may by Law vest the Appointment of such inferior Officers, as they think proper, in the President alone, in the Courts of Law, or in the Heads of Departments.

The President shall have Power to fill up all Vacancies that may happen during the Recess of the Senate, by granting Commissions which shall expire at the End of their next Session.

Section. 3. He shall from time to time give to the Congress Information of the State of the Union, and recommend to their Consideration such Measures as he shall judge necessary and expedient; he may, on extraordinary Occasions, convene both Houses, or either of them, and in Case of Disagreement between them, with Respect to the Time of Adjournment, he may adjourn them to such Time as he shall think proper; he shall receive Ambassadors and other public Ministers; he shall take Care that the Laws be faithfully executed, and shall Commission all the Officers of the United States.

Section. 4. The President, Vice President and all civil Officers of the United States, shall be removed from Office on Impeachment for, and Conviction of, Treason, Bribery, or other high Crimes and Misdemeanors.

ARTICLE. III.

Section. 1. The judicial Power of the United States, shall be vested in one supreme Court, and in such inferior Courts as the Congress may from time to time ordain and establish. The Judges, both of the supreme and inferior Courts, shall hold their Offices during good Behaviour, and shall, at stated Times, receive for their Services, a Compensation, which shall not be diminished during their Continuance in Office.

Section. 2. The judicial Power shall extend to all Cases, in Law and Equity, arising under this Constitution, the Laws of the United States, and Treaties made, or which shall be made, under their Authority;—to all Cases affecting Ambassadors, other public Ministers and Consuls;—to all Cases of admiralty and maritime Jurisdiction;—to Controversies to which the United States shall be a Party;—to Controversies between two or more States;—between

a State and Citizens of another State,—between Citizens of different States,—between Citizens of the same State claiming Lands under Grants of different States, and between a State, or the Citizens thereof, and foreign States, Citizens or Subjects.

In all Cases affecting Ambassadors, other public Ministers and Consuls, and those in which a State shall be Party, the supreme Court shall have original Jurisdiction. In all the other Cases before mentioned, the supreme Court shall have appellate Jurisdiction, both as to Law and Fact, with such Exceptions, and under such Regulations as the Congress shall make.

The Trial of all Crimes, except in Cases of Impeachment, shall be by Jury; and such Trial shall be held in the State where the said Crimes shall have been committed; but when not committed within any State, the Trial shall be at such Place or Places as the Congress may by Law have directed.

Section. 3. Treason against the United States, shall consist only in levying War against them, or in adhering to their Enemies, giving them Aid and Comfort. No Person shall be convicted of Treason unless on the Testimony of two Witnesses to the same overt Act, or on Confession in open Court.

The Congress shall have Power to declare the Punishment of Treason, but no Attainder of Treason shall work Corruption of Blood, or Forfeiture except during the Life of the Person attainted.

ARTICLE. IV.

Section. 1. Full Faith and Credit shall be given in each State to the public Acts, Records, and judicial Proceedings of every other State. And the Congress may by general Laws prescribe the Manner in which such Acts, Records and Proceedings shall be proved, and the Effect thereof.

Section. 2. The Citizens of each State shall be entitled to all Privileges and Immunities of Citizens in the several States.

A Person charged in any State with Treason, Felony, or other Crime, who shall flee from Justice, and be found in another State, shall on Demand of the executive Authority of the State from which he fled, be delivered up, to be removed to the State having Jurisdiction of the Crime.

No Person held to Service or Labour in one State, under the Laws thereof, escaping into another, shall, in Consequence of any Law or Regulation therein, be discharged from such Service or Labour, but shall be delivered up on Claim of the Party to whom such Service or Labour may be due.

Section. 3. New States may be admitted by the Congress into this Union; but no new State shall be formed or erected within the Jurisdiction of any other State; nor any State be formed by the Junction of two or more States, or Parts of States, without the Consent of the Legislatures of the States concerned as well as of the Congress.

The Congress shall have Power to dispose of and make all needful Rules and Regulations respecting the Territory or other Property belonging to the United States; and nothing in this Constitution shall be so construed as to Prejudice any Claims of the United States, or of any particular State.

Section. 4. The United States shall guarantee to every State in this Union a Republican Form of Government, and shall protect each of them against Invasion; and on Application of the Legislature, or of the Executive (when the Legislature cannot be convened), against domestic Violence.

Article. V.

The Congress, whenever two thirds of both Houses shall deem it necessary, shall propose Amendments to this Constitution, or, on the Application of the Legislatures of two thirds of the several States, shall call a Convention for proposing Amendments, which, in either Case, shall be valid to all Intents and Purposes, as Part of this Constitution, when ratified by the Legislatures of three fourths of the several States, or by Conventions in three fourths thereof, as the one or the other Mode of Ratification may be proposed by the Congress; Provided that no Amendment which may be made prior to the Year One thousand eight hundred and eight shall in any Manner affect the first and fourth Clauses in the Ninth Section of the first Article; and that no State, without its Consent, shall be deprived of its equal Suffrage in the Senate.

Article. VI.

All Debts contracted and Engagements entered into, before the Adoption of this Constitution, shall be as valid against the United States under this Constitution, as under the Confederation.

This Constitution, and the Laws of the United States which shall be made in Pursuance thereof; and all Treaties made, or which shall be made, under the Authority of the United States, shall be the supreme Law of the Land; and the Judges in every State shall be bound thereby, any Thing in the Constitution or Laws of any State to the Contrary notwithstanding.

The Senators and Representatives before mentioned, and the Members of the several State Legislatures, and all executive and judicial Officers, both of the United States and of the several States, shall be bound by Oath or Affirmation, to support this Constitution; but no religious Test shall ever be required as a Qualification to any Office or public Trust under the United States.

ARTICLE. VII.

The Ratification of the Conventions of nine States, shall be sufficient for the Establishment of this Constitution between the States so ratifying the Same.

The Word, "the," being interlined between the seventh and eighth Lines of the first Page, The Word "Thirty" being partly written on an Erazure in the fifteenth Line of the first Page, The Words "is tried" being interlined between the thirty second and thirty third Lines of the first Page and the Word "the" being interlined between the forty third and forty fourth Lines of the second Page.

ATTEST WILLIAM JACKSON SECRETARY
done in Convention by the Unanimous Consent of the States present the Seventeenth Day of September in the Year of our Lord one thousand seven hundred and Eighty seven and of the Independance of the United States of America the Twelfth In witness whereof We have hereunto subscribed our Names,

G°. WASHINGTON
Presidt and deputy from Virginia

DELAWARE
Geo: Read
Gunning Bedford jun
John Dickinson
Richard Bassett
Jaco: Broom

MARYLAND
James McHenry
Dan of St Thos. Jenifer
Danl. Carroll

VIRGINIA
John Blair
James Madison Jr.

NORTH CAROLINA
Wm. Blount
Richd. Dobbs Spaight
Hu Williamson

SOUTH CAROLINA
J. Rutledge
Charles Cotesworth Pinckney
Charles Pinckney
Pierce Butler

GEORGIA
William Few
Abr Baldwin

NEW HAMPSHIRE
John Langdon
Nicholas Gilman

MASSACHUSETTS
Nathaniel Gorham
Rufus King

CONNECTICUT
Wm. Saml. Johnson
Roger Sherman

NEW YORK
Alexander Hamilton

NEW JERSEY
Wil: Livingston
David Brearley
Wm. Paterson
Jona: Dayton

PENNSYLVANIA
B Franklin
Thomas Mifflin
Robt. Morris
Geo. Clymer
Thos. FitzSimons
Jared Ingersoll
James Wilson
Gouv Morris

LOCAL (LONG ISLAND) GOVERNMENT DOCUMENTS, 1790

HEADS OF FAMILIES AT THE FIRST CENSUS

The First Census of the United States (1790) comprised an enumeration of the inhabitants of the present states of Connecticut, Delaware, Georgia, Kentucky, Maine, Maryland, Massachusetts, New Hampshire, New Jersey, New York, North Carolina, Pennsylvania, Rhode Island, South Carolina, Tennessee, Vermont and Virginia. The First Census Act was passed at the Second Session of the First Congress and was signed by President Washington on March 1, 1790. The task of making the first enumeration was placed on the President.

Following are some of the census records of Long Island in 1790.

Credit: United States Census Bureau. "Heads of Families at the First Census," 3–4. https://www2.census.gov/prod2/decennial/documents/1790m-02.pdf.

KINGS COUNTY—Continued.

NAME OF HEAD OF FAMILY.	Free white males of 16 years and upward, including heads of families.	Free white males under 16 years.	Free white females, including heads of families.	All other free persons.	Slaves.
BROOKLYN TOWN—con.					
Garrison, John	1		1		
Hicks, Jacob	3		1		3
Albertson, Abert	2	1	1		
Bennet, John	1	2	4		
Vanectt, John	6	3	1		
VanNostrant, John	4	2	2		1
Allen, Nehemiah	4	3	6		
Goodman, Mathew	1		1		
Carpenter, John, Sr	2	1	5	7	
Boerum, John	1		3	1	2
Gelder, Abraham	1	3	1		
Mote, Bigbell	1		3		
Cornwall, Richard	1		2		
Hicks, John	5	1	4	1	
Carpenter, Beth	1		2		
Voorhis, Simon	2	4	4		
Dick, David	1	4	3		
Boerum, Martin	1	1	2		
Field, Joseph	1		2		
Horsefield, Israel	1		2		
Cornwall, Whitehead	2	1	6		
Everitt, Thomas	2	2	4	1	
Doughty, John	1		2		
Downing, Samuel	2	1	3		
Potter, Aaron	1		5		
Tuttle, Brizilla	1		1		
Betts, Silas	1	2	1		
Wright, Thomas	1		1		
Lane, Thomas	1	1	3		
Williams, Henry	1		1		
Polhemus, Theodorus	1	3	4	12	
Brown, Josiah	1	2	1	1	
Plott, John	1		1		
Lefferts, Nautche			4		
Vandervoer, Abraham	2		2		
Rhiarson, John	2	1	3		
Debevoise, Johannes	4		6	9	
Moser, Margaret	2	2	1		
Devooe, David	2	2	1		
Burke, William	3		2		
Bellias, George	1		1		
Brower, John	1	3	1		
Darrel, Paul	1	1	3	1	
Elsworth, William	1	1	1		
Cowenhoven, John R	2	1	3	10	
Powers, George	1	3	3	1	6
Cowenhoven, John	3	1	5	7	
Havens, Benjamin	3	1	3	2	
Havens, Thomas	1		2	3	
Garrison, Samuel W	1	2	1		
Thompson, Elizabeth			2		
Harris, Joyce		2	1		
Truesdal, James	1		1		
Voorhis, John	1	1	2		
Vanderburgh, Richard	1	2	3		
Lefferts, Lefferts	2		2		
Turnbull, Charles	1	3	4	7	
Maud, Joseph	1		2	7	
Lefferts, Barent	3		2	7	
Van Ander, Eleo			2		
Suydam, Lambert	2	2	6	10	
Sproull, John	4		3		
Suydam, Jacobus	1	1	3	8	
Ryder, Amos	1	2	3		
Totten, Gilbert	2		1		
Riarson, John	2		2		
Duryee, John	1	1	1		
Remsen, Jeremiah	1		1	4	
Van der Voort, John	1		6		
Clopper, Peter	1	1	3		
Van der Voort, Peter	1	3	4	7	
Bassly, John	2	2	2		
Suydam, Hendrick	1	1	2		
Nostrant, John	1	1	2		
Rapalje, Tunis	3		2	9	
Kershow, Jacob	1	1	4		
Remsen, George	1		1	5	
Remsen, Jacob	2		3		
Carpenter, Isaac	1	2	3	4	
Boerum, William	2	2	3		
Johnston, Jeremiah	2	2	2	7	
Remsen, Abraham	3		3	7	
Remsen, William	1	5	5	2	
Bloome, Jacob	2	1	4	9	
Schenk, Martin	1	1	1	11	
Skillman, Francis	1	1	2	1	
Riarson, Romulus	1	1	1		
Riarson, Jacob	1	2	5		
Riarson, Martin	1	2	3		
Vanderbelt, Jeremiah	2	2	4	7	
Dubouse, Elisabeth			8		
Cowenhoven, Nicholas	1	1	3		
Atchison, Garret	2	1	3		
Remsen, Cornelius	2	1	3		
Walter, John	3	3	3		

NAME OF HEAD OF FAMILY.	Free white males of 16 years and upward, including heads of families.	Free white males under 16 years.	Free white females, including heads of families.	All other free persons.	Slaves.
BROOKLYN TOWN—con.					
Eagle, Samuel	2	1	6		
Boerum, Nicholas	3	1	1		3
Felter, John	1	2	4		
Brower, Nicholas	5	3	3		2
Van Allen, Ann	2		1		
Read, John		4	3		
Vaeghter, John	1		2		
Smith, Jeremiah	1	1	3		
Luquier, Abrahm, Sr	3		2		13
Van Dyke, Mathew	2	3	5		8
Van Dyke, Nicholas	2		7		6
Luquier, Abrahim, Jr	2	2	2	1	1
Cornwell, Isaac	2	4	2		6
Cornwell, John	1	1	3		4
Suydam, Ferdinand	2		5		4
Cornwell, William	1	1	2		7
Cornwell, Whitehead	1		1		2
Hicks, Charles	2		2		6
Ludlow, Daniel	1		4		3
Hetfield, Mary			2		3
Riehe, John Fred		2	3	1	
Moller, John C	1		3	1	
Debavolsce, Robert	1		3		
Evans, Charles J	4		6	1	
Van Brunt, Helena	1	1	4	5	
Baenley, Francis	4		2		
Campbell, Donald	1		2	5	
Williamson, Garret	1	1	2	1	
Debovolse, Charles	2		2		
Pearson, Thomas	3	6	3		
Brower, Jeremiah	1	1	1		
Brower, Abrahim, Sr	1		2		
Brower, William	2		1		
Brower, Jeremiah	5	2	6		
Johnston, Court	4		3		1
Brower, Abrahim, Jr	4		3		
Brower, Adolphus	2	1	5		3
Cottelyon, Peter I	2		1		1
Tiebout, Tunis	2		1		9
Adrianee, Rem	2		1		6
Van Brunt, Cornelius	1	2	3		5
Berry, Water	1	1	5		5
Smith, Joseph	2	1	2		4
Wychoff, Peter	1	2	4	1	7
Holst, Anthony	3		2		1
Holst, John	1	5	2		1
Bennet, George	5		3		4
Bennet, William, Sr	1	2	3		4
Furman, William	1		3		
Bennet, Jacob	1	1	3		17
Stallingwolff, Jacob	3		5		
Baragon, Tunis, Sr	3	1	5		9
Bennet, Peter	1	1	2		
Moore, Daniel	1	2	1		
Taylor, Peter	1	1	3		
Bennet, Abrahim	1	2	3		
Bogert, Gilbert	2		1		
Bennet, Anthony	1		2		
Baragon, Michol	3	1	1		8
Van Pelt, Wynant, Jr	2	1	4		
Baragon, Michol	1	1	2		10
Van Horne, Jacob	2		2	1	1
Baragon, Tunis I	2	3	1		
Bennet, Jero	1	3	3		
Bennet, Abrahim	2	1	3		
Delaney, Abrahim	1	3	1		
Van Pelt, Wynant, Sr	3	2	1		3
BUSHWICK TOWN.					
De Bevoice, Jacob	3	1	4		5
Cock, Gabriel	4		4		
Waley, Alexander	2	4	3	1	1
Boorham, Jacob	2	4	3		
Schenk, Charity	1		3		
Titus, Leah	1	2	2		1
Williams, Jonathan	1	2	3		
De Bevoice, Charles	1		2		
Van Cotts, Peter	1	2	1		
Broombush, William	2	1	3		
Gilbert, Ebenezar	1		5		
Beedle, Moris	2	1	1		1
Covert, John	2		4		
Wyckoff, Nicholas	2	4	3		
Birdirs, James	4		4		
Schenk, Peter	2	1	2		
Duryee, Charles	2	1	5		
Duryee, Jacob	2	1	2		8
Duryee, Abraham	1		2		
Vandervoort, Francis	2		4		
Bogert, Gilbert	2		2		
Van Allen, Henry	1	4	2		
Bogert, Arola	1	4	3		
Corshow, Tunis	1	1	5		

NAME OF HEAD OF FAMILY.	Free white males of 16 years and upward, including heads of families.	Free white males under 16 years.	Free white females, including heads of families.	All other free persons.	Slaves.
BUSHWICK TOWN—con.					
Duryee, Cornelius	1	2	1		
Van Nance, Abraham	3		2		4
Gibson, David	3	1	3		4
Conslyea, Ann	1	1	2		
Devoe, John, Senr	5		2		
De Bevoise, Isaac	2		3		2
Polhemus, Jacob, Esqr	2		5		8
Conslyea, William	1	2	3		
Bennet, Jacob	2		2		5
Van Cotts, William	1		2		1
Devoe, John, Jr	1	4	2		
Van Horne, Barnet	1		1		
Messerole, John	1	3	1		6
Messerole, Jane	1		1		4
Collier, Peter	3	1	3		2
Messerole, Abraham	2		2		2
Randers, Christiana, and Samuel Larue	2		6		2
Messerole, John, Jr	1	1	4	2	
Harmilbat, John					
Duryee, Peter	1		7		3
Duryee, George	2		1		6
Van Cotts, David	3		2		3
Van Cotts, Jacob	1		2		
De Bevoice, Court	1	1	2		1
Luquire, John	1	1	1		4
Luquire, John, Junr	1	1	3		3
Skilman, John	1	1	3		3
Vandervoort, John, and Petor Collier	2	4	3		1
Storm, Peter	2	4	2		
Van Cotts, David	1	2	2		7
Bennet, William	3	1	3		8
Titus, John	1		3		8
Titus, Francis, and Francis Titus, Junr	2		3		
Titus, Charles	2	2	3		4
Bogert, Abraham, Jr	1	2	3		4
Molliner, David	3		1		1
Conslyea, Andrew	1	2	2		4
Miller, Peter	2		2		
Kershow, Martin	1		2		3
Stockholm, Andrew	2	2	3	1	7
Suydam, Jacob	2		2		11
Duryee, Johannes	1		2		4
Duryee, Gabriel	1		2	1	
Simmons, Benjamin	1		1		
Naffies, Rulaph	2	2	3		4
Duryee, Gabriel	2		1		
FLATBUSH TOWN.					
Suydam, Hendrick	2	1	1		8
Voorhis, Laurence	1	2	2		16
Antonides, Vincent	2		4		
Hagaman, Joseph	1	4	3		7
Disnius, Joannes	1	1	3		7
Disnius, Abrahim	1		1		8
Suydam, Hendrick II	3	1	5		10
Vanderwelt, Cornelius	2	2	5		10
Lott, Johnanos E	2	6	3		10
Suydam, Jacob	2	1	3		8
Vanderwelt, Jacobus	1	1	2		4
Schoomaker, Stephen B	1		2		
Vanderwelt, Hendrick	4	1	4		
Van Beuren, John	1		5		2
Van Cleef, Michael	1		5		
Suydam, Hendrick	1		1		
Bergan, Cornelius	1	4	2		
Low, Peter	1		5		2
Crosby, John	2	1	2	2	2
Haughoman, Petrus	1	3	3		
Antonides, Peter	2		6		
Van Beuren, James	1	1	4		3
Antonides, John, and Tunchy Johnston	1	2	1	8	
Todd, James	1	18	3	2	
Schoomaker, Martin	4	6	3		1
Merril, William	2	1	3		
Waldron, Johannes	2	1	2		
Lefferts, Jacob	1	2	4		5
Stryker, Peter	2	6	3		7
Vanderbelt, John	1		5	4	10
Beck, Daniel	1		5		
Van Beuren, Henry	1		2		
Mortenson, George	2	4	3		8
Nagel, Philip	1	4	2		8
Gifford, William B	2	4	6	1	10
Giles, Aquilla	3	4	6	1	6
Hageman, John	2	5	1		9
Mortinson, Leffert	2		1		
Lefferts, Leffert, and Samuel Garrison	2		2		13
Voorhis, Daniel	2	3	1		1
Vanderbelt, John	1	3	6		10

QUEENS COUNTY—Continued.

NAME OF HEAD OF FAMILY.	Free white males of 16 years and upward, including heads of families.	Free white males under 16 years.	Free white females, including heads of families.	All other free persons.	Slaves.
FLUSHING TOWN—con.					
Wiggins, Benjamin	1	2	2		
Lawrence, Stephen	1	2	2		4
Coaler, Abraham	2		5		
Lawrence, Daniel	2	1	1		
Adriance, Albert	2		1		7
Adriance, Jacob	2	1	1		5
Cornwell, Samuel	2		2		3
Hicks, Norris	1	1	3		1
Thorne, Samuel	2		2		
Cornwell, Obediah	1		3		3
Cornwell, Barack	1	1	7		2
Fowler, Thomas	3	3	4		2
Cornwell, Lewis, Junr	2	3	3		1
Charles (Free)			4		
Thomas, Jack (Free)			1		
Phillis (Free)			6		
Lucey (Free)			1		
Hezekiah (Free)			1		
Andrew (Free)			1		
Sarah (Free)			2		
Van Wyck, Gilbert	3		3		2
Smith, Mary			4		
Valentine, John	2	1	3		
Nesbitt, William	1	1	2		
JAMAICA TOWN.					
Doughty, Jacob	1		2		
Bennet, Ann		3	1		
Valentine, James	3		4		
Doughty, Benjamin	1	3	4		1
Doughty, Micah	2		4		
Doughty, John	2		3		1
Hendrickson, Barnardus	1	5	3		2
Townsend, Nathaniel	2	2	3		
McDavitt, Patrick	2	2	3		1
Valentine, William	2	2	5		
Carpenter, Daniel	1	1	2		
Carpenter, Jacob	1	1	2		4
Foster, William	1	4	3		
Higbey, Nathaniel	1		3		
Bennet, Barnardus	1	2	6		
Barriger, Mary			2		
Barriger, John	2	2	5		
Hester (Free)					6
Barriger, Theunis	2	1	4		
Barriger, Luke	2	3	4		3
Everitt, John	2	3	2		
Barringer, Dick	2		2		
Carpenter, Increase	3	2	2		2
Messenger, John	1	1	4		
Wiggins, Richard	1	1	7		1
Everitt, Benjamin	1		4		
Skidmore, John I	2		3		
Puntine, William	1		4		
Duryce, Ruloph, Junr	2	1	4		
Messenger, Sarah			4		
Smith, Daniel	3	2	6		1
Rhoads, Richard	2	1	2		
Smith, John	2		4		
Messenger, William	2	3	3		
Fleet, Philetus	1		3		
Forbes, William	1		1		1
Tuthill, Abraham	1	2	3		1
Smith, Joseph	1	1	1		
Robinson, Joseph	1		5		3
Mills, Amos	3	1	4		
Denton, Nathaniel	2		3		1
Messenger, Nehemiah	3		2		
Van Nostrandt, Aaron	3		1		
Solomon (Free)					2
Van Low, James	1	1	2		
Denton, Timothy	1	1			2
Denton, Samuel	1		2		
Smith, Mary			2		
Carpenter, Benjamin	2		5		
Skinner, Abraham	1	3	2		1
Frank (Free)			1		
Lewis, William	1	4	3		
Ludlum, Nicholas	2	2	2		
Vaile, Samuel	5	2	2		
Tuthill, Daniel	5		1		
Pettit, Theasia			2		
Mills, Sarah			2		
Herriman, Stephen	8		4		
Foster, James	2	1	4		
Smith, James	2		3		1
Jones, John	2		1		
Van Dam, Richard	1		3		
Lambertson, David	1	2	3		
Lambertson, Jane		2	2		
Mackrel, James	4		2		
Hinchman, Patience			3		

NAME OF HEAD OF FAMILY.	Free white males of 16 years and upward, including heads of families.	Free white males under 16 years.	Free white females, including heads of families.	All other free persons.	Slaves.
JAMAICA TOWN—con.					
Morris, Joseph	1	1	2		
Lewis, Sarah			3		
Waters, James	2	1	3		2
Hinchman, Ann			3		
Harriman, James	2	2	3		
Smith, Platt	2	1	1		
Mills, James	4	1	1		
Lattin, Sarah			3		
Dudley, John	3		3		
De Poyster, James	3		6		
Faitout, George	1	2	5		
Isaac (Free)				4	
Van Pelt, Jacob	2	1	4		
Fairchild, Seth	1	1	2		1
Warne, William	2	1	4		
Thurston, Mary			2		
Fan (Free)				1	
Keth, James	1		4		
Creed, William, Junr	2	1	4		2
Mary (Free)				4	
Sylvester (Free)				6	
Ishmael (Free)				3	
Hinchman, Nehemiah	3	1	3		
Hinchman, John	2	3	3		
Sprung, David	1	2	3		
Falconor, John	2	2	3		
Mills, Joshua	1	1	3		
Ditman, John	2		3		
Tronp, John	1	1	2		
Smith, Nehemiah	1	1	3		
Smith, Othaniel	2		2		
Ludlum, Nehemiah	1	1	5		
Higbee, Mosis	2		1		
Ludlum, William	2		4		
Ludlum, Daniel	2	1	2		
Oakley, Andrew	1	1	4		
Smith, Samuel	1		4		
Rhoads, Richard, Junr	1	1	4		
Oldfield, Joseph	2		4		
Rhoads, John	3		4		
Ludlum, John	2	1	3		
Bennet, John	1	2	2		
Bennet, Isaac	1		3		
Wiggins, Henry	1		2		
Hendrickson, Uriah	1	2	2		
Seeley, Joseph	1		2		
Oldfield, Jane	1	1	2		
Cornwell, Samuel	1		2		
Martin, William	1	1	3		
Covert, Theunis	3	1	2		
Martin, Thomas	1	1	3		
Mills, Samuel	2		3		
Everitt, Benjamin, Junr	1		1		
Hendrickson, William	2	1	2		
Hendrickson, Abraham	1		3		
Mills, Henry	2		3		
Hendrickson, Hendrick	2		3		4
Ballis, Daniel	2		2		
Boughram, Orrey	2	3	3		
Ballis, Ephraim	2		1		
Remsen, John	1		1		
Remsen, Orrey	2		4		
Amerman, Isaac	1	1	4		
Nostrand, John	3	1	2		
Holland, Richard	1	2	2		
Nostrand, Garret	1		2		
Nostrand, Peter	2	2	4		
Bennet, Cornelius	2	1	2		
Goldor, Abraham	1	1	1		
Ballis, Ephraim, Junr	1		1		
Schnedecker, Isaac	1		1		
Goldor, William	5	4	2		
Smith, Nathaniel, Senr	1		5		
Lambertson, Bernardus	1		5		
Higbie, John	1		5		
Covert, Isaac	2		5		
Mills, John	2		2		
Losic, John	2	2	4		
Mills, Samuel	1		2		
Van Alstol, Abraham	1		6		
Amerman, Isaac, Junr	1		4		
Hendrickson, John, Junr	1		5		
Cornwell, Samuel, Junr	1		5		4
Hendrickson, Aaron	3		3		
Hendrickson, Nicholas	1		4		
Lambertson, Simeon	3		4		
Carpenter, Nehemiah	1	1	4		
Higbie, Stephen	1		3		
Hendrickson, Peter	2		2		
Amerman, John	1	3	2		
Higbie, Daniel	1		3		
Higbie, John	2		2		
Everitt, Nicholas	1	2	4		
Higbie, Henry	3	3	7		
Smith, Joseph	1		2		

NAME OF HEAD OF FAMILY.	Free white males of 16 years and upward, including heads of families.	Free white males under 16 years.	Free white females, including heads of families.	All other free persons.	Slaves.
JAMAICA TOWN—con.					
Ross, Charles	1	2	5		
Stine, Peter	1	5	1		
Yandle, Joseph	1	1	5		
Seaman, Samuel	2	1	6		
Mills, Nathaniel	2	1	6		
Rider, Urias	3		2		
Amerman, John	1	4	3		
Carpenter, Jacob, Junr	1	2	5		
Carpenter, Nathaniel	2	1	3		1
Lambertson, Waters	1	4	3		
Smith, Walter	1	1	4		
Brimmer, John	3	1	6		
Ludlum, William	2	1	4		
Smith, Nicholas	2	2	7		
Smith, Christopher	1		4		9
John (Free)			2	2	
Dewitt, Jacob	1	1	4		
Pettit, Isaac	1		2		
Peg (Free)			4		1
Van Est, Rinear			2		4
Brownjhon, Samuel	1	3	3		1
David (Free)				5	
Kottletas, Abraham	3		6		
Hicks, George	3		3		
Betts, Richard	3	1	3		
Lefferts, Isaac	4		2		2
Polhomus, Johannus	2	3	3		4
Welling, Samuel	1		1		
Welling, Thomas	1	1	2		
Bott (Free)				1	
Winkoff, John	1	4	2		3
Schnydecker, Rem	1	4	1		
Bennet, Barnet	1	5	5		11
Lott, Hendrick	4	1	4		5
Lott, Stephen	2	1	4		3
Furman, John	2	1	1		3
Blard, Samuel	1		1		
Wortman, John S	4				
Elizabeth (Free)			4		
Creed, Howiet	3		2		1
Emmons, Hendrick	2	1	3		
Sam (Free)				3	
Schnydecker, Garret	2	1	1		
Remsen, Jeremiah	3		1		
Templeton, Oliver	3	1	5		
Van Wicklen, Garret	3	2	2		
Schnydecker, John	1	1	4		
Lott, John	1	1		1	
Schnydecker, John, Junr	1		1		
Linington, Stephen	1		2		
Rider, James	2		1		
Remsen, Daniel	1	2	2		
Remsen, John	2	1	1		
Jones, Nicholas	2	1			
Uuderhill, Jonathan	1	1	1		
Durland, Elizabeth			2		
Durland, Garret	2	2	3		
Bonigen, Jacob	2	3	4		
Doughty, Samuel	5		1		9
Elias (Free)				3	
Israel (Free)				6	
Marston, Francis	2		1		
Covert, Dick	1	1	3		5
Santon, Townsend			1		
Gilbort, Ross			1		
Lott, Johannus II	2	4	2		2
Ditmus, Abraham	2	2	4		
Smith, Deborah			2		
Lott, Abraham	4	2	2		
Creed, William	3	2	2		1
Smith, Thomas	1	2	2		1
Denton, James	2	3	2		1
Smith, John, 3d	3		2		
Denton, Amos	2		1		2
Thatford, John	2	1	1		
Williamson, John	2		1		3
Rhoads, Nathaniel	1	2	4		1
Willing, Charles	2		2		
Van Brunt, Yost	3	1	6		8
Rhoads, Blathur	2		2		
Travis, Elisha	1		1		
Rapelje, Daniel	2	1	1		2
Duryce, John	2	1	2		
Cole, Thomas	2	2	2		
Murphy, Garret	2		1		
Boss, Jack (Free)				3	
Smith, John, 3d	2	1	1		1
Myers, John	1	2	5		
Morrel, James	1	2	3		
Denton, William	1		1		
Van Leer, John	1	2	4		2
Waters, William	1		2		2
Jack (Free)				1	
Aaron (Free)				1	

SUFFOLK COUNTY—Continued.

NAME OF HEAD OF FAMILY.	Free white males of 16 years and upward, including heads of families.	Free white males under 16 years.	Free white females, including heads of families.	All other free persons.	Slaves.
BROOKHAVEN TOWN—continued.					
Tucker, Wm.	1	1	1
Hawkins, John.	1	3	1	..	1
Farrington, Thos.	1	1	1
Gavol, John.	1	..	1
Hawkins, Alexander.	1	..	3	1	..
Hawkins, Jacob.	1	4	2	..	1
Hawkins, Simeon.	1	1	5
Hawkins, Saml.	3	..	6	..	1
Smith, Thos.	1
Tucker, Phillip.	2	..	3
Tucker, Joseph.	1	1	2
Eckley, Elijah.	2	..	1
Eckley, Elijah, Senr.	1	..	1
Anthony, Tonoy.	6	..
Davis, Clark.	3	..	2
Hawkins, Benjamin.	1	1	2
Hawkins, Eleazor.	1	..	2
Smith, Selah.	1	..	1
Tucker, Natl.	2	..	3
Jack, John.	2	..
Smith, Age.	2	2	3
Mapes, James.	2	1	2
Thompson, Saml.	1	..	2	2	2
Bayley, John.	3	2	5
Clark, Cornelius.	1	..	1
Hawkins, Thos.	1	..	2
Tucker, Timothy.	1	2	2
Tucker, Jonah.	1	1	3
Hawkins, Caleb.	1	..	1
Smith, Amos.	2	3	4	1	..
Bigg, Isaac.	2	..	2
Bigg, John.	2	..	1
Smith, Isaac.	3	..	3	..	1
Pandicson, Sarah.	1
Kelley, Shaderick.	1	1	1	2	..
Cornwell, Robert.	1	..	1	2	..
Mount, Thos.	2	..	5
Jane, Wm.	2	3	1
Bayley, Nicl.	1	..	1
Jones, Ebenezar.	1	..	1
Jones, Vincent.	1	..	1	1	..
Mills, Jonathan.	2	2	4
Hawkins, Isaac.	1	1	4
Dickerson, Jonathan.	3	3	1
Muteson, Margaret.	2
Certias, John.	1	..	2
Davies, George.	2	..	4
Hawkins, Edward.	1	..	2
Halock, Jonathan.	1	..	2
Hallock, David.	1	1	2
Bayley, Elijah.	2	..	3
Hawkins, Israel.	1	..	1	2	..
Saterley, Danl.	2	..	4
Bennott, Israel.	1	1	1	1	..
Dallas, Charles.	1	..	1	..	2
Woodhull, Nathan.	1	..	1	..	2
Woodhull, Natl, Junr.	1	2	..	1	..
Smith, Gilbert.	1	..	4	1	1
Woodhull, Abm.	1	..	1	1	3
Strong, Selah.	2	2	2	1	1
Helves, Ben.	6	..
Rhoe, Phillip.	3	..	5	1	..
Comstock, Danl.	1	2	1	1	..
Roche, Ruth.	2
Worth, Labon.	1	..	1
Porter, John.	1	..	1
Gomez, Danl.	1	..	2	1	1
Boatwick, Jesse.	..	1	2
Jane, Wm.	1	..	1
Hulet, David.	1	1	1
Tucker, Ruth.	..	1	4
Smith, Danl.	3	2	3	2	..
Hulst, Ebenezar.	2	..	2
Mark, Sharp.	2	..
Jones, Saml.	1	..	3	2	1
Jones, Stephen.	2	3	2	1	..
Jones, Robert.	2	..	2	..	3
Brunt, Jacob B.	2	2	2	1	3
Rhoe, Augustus.	3	2	5	1	..
Jones, Benjn.	1	..	3	3	..
King, George.	2	1
Colley, Henry.	1	..	1	1	..
Taylor, Benjn.	3	1	5
Robins, Isaac.	1	..	6
Jones, Robert, Junr.	1	1	4	..	1
Hulst, Jesse.	2	1	4	1	..
Huxton, James.	1	1	4	1	..
Hulst, Gilbert.	1	1	4	1	..
Mills, Micah.	1	..	5
Tucker, Wm.	1	1	2
Saterley, Ellison.	2	3	4
Smith, James.	1	..	2	1	..
Edwards, Stephen.	3	1	2	1	..
Bruster, Joseph.	3	1	4	1	3
Whitmon, Noah.	1	..	1
Shiley, Joseph.	2	..	4	1	..

NAME OF HEAD OF FAMILY.	Free white males of 16 years and upward, including heads of families.	Free white males under 16 years.	Free white females, including heads of families.	All other free persons.	Slaves.
BROOKHAVEN TOWN—continued.					
Floyd, Benjn.	3	7	2
Lisscomb, Elias.	1	1	2
Divick, Richd.	1	..	1
Black, Clorah.	6	..
Blurch, Cato.	5	..
Woodhul, Titus.	2	..
Simonds, Jane.	1
Longbotham, Saml.	1	..	6	..	1
Hawkins, Eleazer.	1	..	4	..	4
Hawkins, Jonas.	1	4	4	..	2
Parker, Wm.	1	4	1
Longbotham, Wm.	2	..	2
Mills, Saml.	1	4	3
Smith, Henry.	1	1	2
Hallock, William.	1	1	3	..	1
Davies, Jonas.	1	1	5
Davies, Isaac.	2	3	6
Davies, Caleb.	1	2	4
Hawkins, Wm.	1	3	2	..	1
Hawkins, Joseph.	1	..	1
Rutyard, Thos.	3	1	3
Williamson, Jedediah.	1	1	1
Okee, John.	1	3	2
Smith, David.	1	1	3
Wills, Joseph.	1	2	1
Hallock, George.	1	3	2
Davis, Joseph.	1
Hallock, Henry.	1	4	2
Davis, Phenius.	2	1	3
EASTHAMPTON TOWN.					
Raymond, Wm.	1	..	1
Richmond, Warnor.	1	1	3
Hedges, Jeremiah.	1	..	1
Norris, Henry.	2	..	1
Corey, Abm.	1	..	1
Dalng, Lewis.	..	1	2	1	..
Jagger, Abigail.	2
Denison, Nathan.	1	2	3	2	..
Conkline, Annias.	2
Conkline, Joseph.	1	..	5	1	..
Conkline, Joseph, Junr.	1	..	1	1	..
Coleburn, Josiah.	1	1	1	1	..
Boley, Nathaniel.	3	..	4	1	..
Trion, Elisha.	2	1	..
Clark, Moses.	1	1	3
Conkline, Abigail.	3
Strong, John.	1	..	1
Strong, Talmage.	..	2	3
Strong, John, Junr.	1	3	3
Edwards, Steven.	1	3	2
Miller, Thos.
Strong, George.	1	..	2
Tamago, Eros.	2	2	2	1	..
Tamago, Thos.	1
Hand, Silas.	2	..	2
Hand, James.	1	1	2
Hand, Mary.	4
Osburn, Elisha.	3	1	4
Osburn, Thos.	4	..	2
Osburn, Elisha.	4	..	5
Topping, Benjn.	2	..	7
Conkline, Elisha.	2	..	1	..	1
Osburn, Jacob.	1	..	7
Osburn, Jonth.	2	..	4
Miller, Wm.	1	..	2
Dayton, John.	2	2	2	1	2
Jones, Jeremiah.	1	..	2
Jones, Edward.	1	1	6
Demming, Isaac.	1	1	1
Demming, Abm.	3	..	2
Demming, Abm, Junr.	1	1	1
Tamago, Jeremiah.	1	..	1
Osburn, Cornelius.	1	..	1
Hand, Abigail.	2
Gold, Patrick.	3	..	1
Jones, Ezekiel.	2	1
Dayton, Danl.	4	..	1	3	1
Straton, Stephen.	4	..	2	1	..
Hedges, Mathew.	2	2	7
Miller, John.	2	2	4	..	3
Dayton, David.	2	1	4
Barnes, Noah.	2	..	3
Barnes, Seth.	2	4	2
Mulford, Nathan.	1	1	4	2	..
Osburn, Phebe.	1	3	3
Osburn, Jeremiah.	1	3	4	4	2
Osburn, Mary.	2	1	..
Tabnag, Thos.	2	1	..
Babcock, Steph.	1	2	1
Osburn, Jerusha.	3
Hedges, Danl.	2	2	8	1	5
Hedges, Nathan.	2	..	2
Catfield, John.	3	1	..

NAME OF HEAD OF FAMILY.	Free white males of 16 years and upward, including heads of families.	Free white males under 16 years.	Free white females, including heads of families.	All other free persons.	Slaves.
EASTHAMPTON TOWN—continued.					
Chatfield, Henry.	1	2	1
Isaaks, Aaron, Junr.	1	2	2
Jones, Eliza.	2
How, John.	2
Conkline, Martha.	3
Mumford, David.	2	..	5
Hand, Abm.	3	2	2	2	..
Hedges, Jonoth.	1	..	1
Hedges, Rubin.	1	1	3	..	7
Miller, Jeremiah.	2	..	1
Miller, Hunting.	3
Miller, Jeremiah, Junr.	1	1	3	..	4
Mulford, Elisha, Junr.	2	..	2	5	..
Mulford, Elisha, Senr.	1	..	3	2	2
Bowell, Saml.	1	..	3	..	5
Hedges, Elisheu.	1	..	2
Hedges, Wm.	1	1	5
Sage, Ebenezar.	1	..	1
Gardiner, Abm.	1	3	2	1	5
Isaacks, Aaron.	1	1	1
Isaacks, Saml.	2	1	..
Hedges, Benjn.	1	..	2	1	..
Hedges, Phillip.	1	..	4
Hedges, Christopher.	1	1	4
Hand, Jacob.	1	..	4
Hand, Jerod.	1	..	2
Miller, Abm.	2	..	2	3	1
Wickham, Isaac.	1	..	2
Isaacks, Isaac.	3	..	1
Shud, Recompense.	..	3	3
Shud, Abm.	1	..	1
Conkline, Stephen.	1	..	4
Phlar, Thos.	1	..	4	1	..
Hunton, Wm.	1	..	2
Osburn, Joseph.	1	4	1
Osburn, Jonothan.	1	..	2	1	..
Osburn, Henry.	1	..	2
Osburn, Danl.	1	..	2
Hunton, Natl.	2	1	4	2	..
Gardiner, Mary.	2	3	..
Conkline, Jeremiah, Junr.	1	..	4
Mulford, Jonathan.	1	..	3
Mulford, Josiah.	1	1	3	1	..
Tuttle, Jonithan.	1	2	1	2	..
Baker, Thos.	1	..	2	1	..
Dayton, Jesse.	1	..	4
Hutleson, Hannah.	1
Mulford, Wm.	1	1	3
Conkline, Jon.	1	..	3
Poppin, David.	5	..	3
Davis, John.	1	3	3
Gardiner, John.	1	..	3
Conkline, Mulford.	1	..	4	5	..
Lester, John.	4	..	5	2	..
Bennett, Jeremiah.	1	..	2	5	..
Loper, Amos.	1	..	1
Mulford, Jonothan, Senr.	1	..	2	2	2
Hedges, Ebenezar.	1	..	2
Skoy, Isaac, Junr.	1	..	2
Pearsons, Henry.	3	..	3
Skoy, Isaac, Senr.	3	..	2
Rangor, Saml.	3	..	2
Pearson, Stephen.	1	..	6
Terril, Jeremiah.	1	..	2
Pearsons, Eli.	1	..	2
Domenick, Henry.	1	..	1	1	..
Straton, Jeremy.	2
Parsons, John.	3
Pearsons, John, 4th.	1	..	2
Tithehows, Phebe.	2
Straton, Mathew.	2	..	2
Pearsons, Ludlum.	3	3	1	..	1
Mulford, John.	1	..	1
Davis, Elisha.	1	3	8
Pearsons, Samuel.	1	1	8
Pearsons, Merin.	2	4	3
Miller, David.	2	4	5
Miller, David.	1	1	6
Pearsons, John, 5th.	2	..	4	4	1
Pearson, John, 6th.	1	..	5
Pearson, Seth.	1	1	6
Miller, Elisha.	1	1	6
Bennett, Gambriel.	1	2	4
Barnett, Edward.	1	1	3
King, Danl.	1	..	2
King, Richd.	1	2	2
King, Frederick.	1	..	1
Tamage, David.	4	..	2
Miller, Zhitomy.	2	..	2
King, John.	4	..	3
Pearsons, Robert.	4	..	3
Zobbins, Joseph.	4	1	3
Mulford, Mathew.	4	1	3
Gardiner, John.	4	..	6	1	9
Bennett, Zebulon.	1	..	4
Field, James.	1	2	4

NOTES

Introduction

1. National Park Service, "Battle of Long Island."
2. Bailey, *Long Island*, 416.
3. Morris, *Encyclopedia of American History*, 109.
4. Ramsay, *Life of George Washington*, 161.
5. Ibid., 163–65.
6. Hattem, "Newburgh Conspiracy."
7. Washington's State Historic Site, Newburg Address.
8. Ibid.
9. Lossing, "Results of the American Revolution."
10. Historic Northampton Museum and Education Center, "Shays' Rebellion."
11. Ibid.
12. Maryland State Archives, "Mount Vernon Compact of the Annapolis Convention."
13. *Mount Vernon Compact 2*.
14. George Washington's Mount Vernon, "First in War, First in Peace."

Chapter 1

15. Irving, *Life of George Washington*, 1,392.
16. Ibid.
17. Goler, *Capital City*.
18. Ullman, *Landmark History of New York*, 45.
19. Spaulding, *New York in the Critical Period*, 270.
20. Hattem, "New York."
21. *Federal Hall*, National Park Service.

22. Ellis, *Epic of New York City*, 185.
23. Ibid., 186–88.
24. Washington's Inaugural Address of 1789.
25. Little, *George Washington*, 362.
26. Bowery Boys, "George Washington Slept Here!?"
27. Hemstreet, *When Old New York Was Young*, 213–14.
28. Ullman, *Landmark History of New York*, 154.
29. Ibid.
30. Ibid. 45.
31. Lossing, *Diary of George Washington*, 118.
32. Trinity Church, Wall Street, "History."
33. Spaulding, *New York in the Critical Period*, 12.
34. Trinity Church, Wall Street, "St. Paul's Chapel."
35. Ibid., "History of St. Paul's Chapel."
36. McAtamney, *Cradle Days of New York*, 88.
37. Ibid., 91.
38. All Things Hamilton, "Thomas Jefferson's Residence."
39. Morse, *American Statesman*, 99.
40. Ibid., 100.
41. Rothstein, "Founder's at Home."
42. Bowers, *Jefferson and Hamilton*, 24, 26.
43. Ibid.
44. *George Washington's New York*.
45. Marshall, *Colonial Hempstead*, 81–82.
46. Decatur, *Private Affairs of George Washington*, 310.

Chapter 2

47. Lossing, *Diary of George Washington*, 121.
48. Sayville Historical Society, "History of Early Sayville."
49. Naylor, *Journeys on Old Long Island*, 53.
50. George Washington's Mount Vernon, "George Washington the Farmer."
51. *Queens Jewels*.
52. Naylor, *Journeys on Old Long Island*, 53.
53. Ostrander, *History of the City of Brooklyn and Kings County*, vol. 2, 1–2.
54. Ibid., 34.
55. Ibid., 35.
56. Ibid., 36.

57. Stiles, *History of Brooklyn*, vol. 1, 377.
58. Irving, *Life of George Washington*, 36.
59. Ibid., 38.
60. Ibid., 40.
61. Ibid., 60.
62. Ibid., 67.
63. Strong, *History of Flatbush in Kings County*, 96.
64. Friends of Historic New Utrecht, "History."
65. Bangs, *Reminiscences of Old New Utrecht and Gowanus*.
66. Founders Online, "George Washington."
67. Naylor, *Journeys on Old Long Island*, 59.
68. Haworth, *George Washington: Farmer*, 3.
69. Ibid., 6–7.
70. Washington, *Agricultural Papers of George Washington*, 17.
71. Ibid., 93.
72. Brooklyn Brainery, "Brooklyn's Original Six Villages: Gravesend."
73. Croghan, "You Say You Want a Revolution."
74. Prime, *History of Long Island*, 338.
75. Lossing, *Diary of George Washington*, 121–22.
76. Ibid., *Harper's Encyclopedia of United States History*, 407.

Chapter 3

77. Lossing, *Diary of George Washington*, 122.
78. Grasso, *American Revolution on Long Island*, 18.
79. Ibid., 30–31.
80. Ibid., 42.
81. *History of Queens County, New York*, 225.
82. Ibid., 226.
83. Naylor, *Journeys on Old Long Island*, 59.
84. Riker, *Annals of Newtown in Queens*, 218.
85. Ibid., 221.
86. Ibid., 222.
87. Ibid., 223–24.
88. Hazelton, *Borough of Brooklyn and Queens Counties*, 939.
89. Waller, *History of the Town of Flushing*, 162–63.
90. Ibid., 164.
91. Flexner, *George Washington and the New Nation*, 275.

92. Ross, *History of Long Island*, vol. 1, 532.
93. *Long Island Tercentenary 1936*, 5.
94. New York City Parks, "Rufus King Park."
95. Lossing, *Diary of George Washington*, 123.
96. Bailey, *Long Island*, 101.
97. Ibid., 10.
98. "Hempstead Town at a Glance," 8.
99. Hibbard, *Rock Hall*, 69, 15.
100. Moore, *History of St. George's Church*, 141.
101. Ibid., 142.
102. Town of Hempstead Landmarks Preservation Commission, 7, 12.
103. Cox, *Oyster Bay Town Records*, vol. 7, 202.
104. Lossing, *Diary of George Washington*, 123.
105. Bailey, *Long Island*, 101.

Chapter 4

106. Eide, *Copiague*, 14.
107. Lossing, *Diary of George Washington*, 123.
108. Bailey, *Long Island*, 101.
109. See *Sagtikos Manor*.
110. Ibid., 2.
111. Lossing, *Diary of George Washington*, 123.
112. Blair, "1683: Suffolk County Formed," A43.
113. *Bicentennial History of Suffolk County*, 16.
114. Lossing, *Diary of George Washington*, 124.
115. Horsley, "Ecologists Join Politicians."
116. Stryker-Rodda, "George Washington and Long Island," 17.
117. Bailey, *Long Island*, 101.
118. Stryker-Rodda, "George Washington and Long Island," 13–14.
119. Bailey, *Long Island*, 101.
120. *Long Island Tercentenary 1936*, 5.
121. Long Island Stories, "Harts Tavern Mystery," 3–4.
122. Sincock, *America's Early Taverns*, introduction.
123. Smucker, "Washington on the Dance Floor."
124. Lathrop, *Early American Inns and Taverns*, 342, 345.
125. Thompson, "George Washington and Taverns."
126. Ibid., "Birthnight Balls."

127. Bailey, *Long Island*, 102.
128. See *Patchogue: A Brief History*.
129. Halsey, *Indians of Long Island*, 8–9, 23.

Chapter 5

130. Lossing, *Diary of George Washington*, 124.
131. George Washington's Mount Vernon, "Surveying."
132. Ibid., "Surveying Career."
133. Ibid.
134. Founders Online, "George Washington."
135. Prime, *History of Long Island*, 16.
136. Ibid., 18–19.
137. Tallmadge, *Memoir of Col. Benjamin Tallmadge*, 40.
138. Long Island Genealogy, "History of Coram," 2.
139. Lossing, *Diary of George Washington*, 124.
140. Adkins, *Setauket*, 51.
141. Special Collections at Hofstra University, "250 Years in Suffolk."
142. Roe Tavern website.
143. Adkins, *Setauket*, 53, 52.
144. Stryker-Rodda, "George Washington and Long Island," 17–18.
145. Lossing, *Diary of George Washington*, 125.
146. Stryker-Rodda, "George Washington and Long Island," 18.
147. Smith, *History of Smithtown*, 15.
148. Pelletreau, *History of Long Island*, vol. 2.
149. *Smithtown News*, "Smithtown Washington Saw."
150. Scott and Klaffky, *History of the Joseph Lloyd Manor House*, 27.
151. Ibid., 28–29.
152. "Old Huntington Green Incorporated: A History of Preservation."
153. Hughes, "Brief Guide."
154. Lossing, *Diary of George Washington*, 125.
155. Metcalf, *Brief History of the Arsenal*.
156. Huntington Historical Society, "1750 David Conklin Farmhouse Museum."
157. Ibid., "Historical Guide to Huntington."

Chapter 6

158. Lossing, *Diary of George Washington*, 125.
159. Magnani, "Captain Daniel Youngs."
160. Stryker-Rodda, "George Washington and Long Island," 17–18.
161. Clinton, "Guess Who Slept Here."
162. Pelletreau, *History of Long Island*, vol. 2, 131–32.
163. Friends of Raynham Hall, "Raynham Hall Museum."
164. Stevens, *Discovering Long Island*, 19.
165. Ibid., 21.
166. Johnston, *Memoir of Col. Benjamin Tallmadge*, 51–55.
167. Bleyer, "Spy Sleuth," A8.
168. Kolchin. *American Slavery*, 71.
169. Bleyer, "Spy Sleuth."
170. Gish, *Smithtown, New York*, 75.

Chapter 7

171. Lossing, *Diary of George Washington*, 125–26.
172. Coles and Russell, "Glen Cove in the American Revolutionary War," 39–40.
173. Coles and Van Santvoord, *History of Glen Cove*, 20.
174. Smits, "Creation of Nassau County," 4.
175. Ibid., 7.
176. Thompson, *History of Long Island*, vol. 3, 188.
177. Smits, "Creating a New Nassau County," 129.
178. George Washington's Mount Vernon, "Ten Facts About the Grist Mill."
179. Roslyn Landmark Society, Paper Mill, 2016 House Tour No. 7.
180. Moger, *Roslyn Then and Now*, 63.
181. Gerry and Gerry, *Old Roslyn*, 19.
182. Stryker-Rodda, "George Washington and Long Island," 19.
183. Brower, *Story of the Roslyn Grist Mill*, 11.
184. Archives of the Roslyn Library, "History of the George Washington Manor."
185. *Newsday*, "It Happened on Long Island: 1680: Van Nostrand–Starkins House Is Built in Roslyn," March 13, 2008.
186. Roslyn Landmark Society, Van Nostrand–Starkins House, 2016 House Tour No. 9.

Chapter 8

187. Lossing, *Diary of George Washington*, 126.
188. Sands-Willet House.
189. Blumlein and Williams, *Thomas Dodge Homestead*.
190. *This Is Great Neck*, 15.
191. Ibid., 16–17.
192. Flushing Meeting Religious Society of Friends, "Historic Meetinghouse."
193. Rines, *Old Historic Churches of America*, 134.
194. Grasso, *American Revolution on Long Island*, 68–69.
195. "St. John's Episcopal Church: Oakdale, Long Island."
196. Town of Islip, "Town of Islip Celebration of 200th Anniversary."
197. Caroline Church of Brookhaven, "Brief History of Caroline Church."
198. Miller, "Old First Presbyterian Church of Huntington."
199. New York Yearly Meeting, "History of Manhasset Meeting."

Chapter 9

200 Lossing, *Diary of George Washington*, 126–28.
201. Ruff, "Beacons for All," 146–47, 149.
202. Thomas Jefferson Monticello, "Northern Tour of 1791."
203. Ibid.
204. DeWan, "Island Washington Saw."
205. Wilson, *Long Island's Story*, 181.

BIBLIOGRAPHY

Adkins, Edwin P. *Setauket: The First Three Hundred Years, 1655–1955.* East Setauket, NY: Three Village Historical Society, 1980.

All Things Hamilton. "Thomas Jefferson's Residence." http://allthingshamilton.com/index,php/aph-home/72-aph-new-york-city/167-57-maiden-lane.

Archives of the Roslyn Library. "A History of the George Washington Manor."

Bailey, Paul, ed. *Long Island: A History of Two Great Counties, Nassau and Suffolk.* New York: Historical Publishing Company, 1949.

Bangs, Charlotte Rebecca. *Reminscences of Old New Utrecht and Gowanus.* New York: Brooklyn Eagle, 1912. http://www.archive.org/details/reminiscencesofo00bangiala.

Bicentennial History of Suffolk County. Babylon, NY: Budget Steam Print, 1885.

Blair, Cynthia. "1683: Suffolk County Formed: It Happened on Long Island." *Newsday*, August 28, 2007, A43.

Bleyer, Bill. "Hot On George Washington's Trail: 50-Mile Route Marks Visit of First President." *Newsday*, February 16, 1996.

———. "Oyster Bay's Slave Times." *Newsday*, September 25, 2005.

———. "The Spy Sleuth." *Newsday*, November 9, 2016, A8–A9.

Blumlein, Fred, and George Williams. *The Thomas Dodge Homestead.* Port Washington, NY: Cow Neck Peninsula Historical Society, n.d.

Bowers, Claude G. *Jefferson and Hamilton.* New York: Houghton Mifflin Company, 1925.

The Bowery Boys: New York City History. "George Washington Slept Here?!" January 7, 2008. http://www.boweryboyshistory.com/2008/01/george-washington-slept-here.html.

Brooke, Walter Edwin, ed. *The Agricultural Papers of George Washington.* Boston: Richard G. Badger, Gorham Press, 1919. https://archive.org/details/agriculturalpape00wash.

Brooklyn Brainery. "Brooklyn's Original Six Villages: Gravesend." https://brooklynbrainery.com/blog/brooklyn-s-original-six-villages-gravesend.

Brower, Marion Willets. *The Story of the Roslyn Grist Mill.* Roslyn, NY: Roslyn Grist Mill Board of Trustees, 1953.

Caroline Church of Brookhaven. "A Brief History of Caroline Church." http://www.carolinechurch.org/welcome/history.shmtl.

Clinton, Audrey. "Guess Who Slept Here." *Newsday,* February 18, 1974.

———. "Sagtikos Manor." *Newsday,* August 17, 2013.

Coles, Robert R., and Daniel E. Russell. "Glen Cove in the American Revolutionary War." Booklet. Robert R. Cole Long Island History Room, Glen Cove Library, n.d.

Coles, Robert R., and Peter Luyster Van Santvoord. *A History of Glen Cove, Published on the Occasion of the Glen Cove Tricentennial, 1668–1968.* Glen Cove, NY: privately published, 1967.

Cox, John, Jr. *Oyster Bay Town Records.* Vol. 7, *1764–1795.* New York, 1938.

Croghan, Lore. "You Say You Want a Revolution: Charles M. Ryder House, 32 Village Road North." *Brooklyn Daily Eagle,* n.d. http://www.brooklyneaglecom/articles/2014/8/27/brooklyn-revolutionary-war-houses-charles-m-ryder-gravesend.

Davis, Alma Q. "History of Coram: An Unjust Settlement." Coram Civic Association. http://www.coramcivic.org/HistoryofCoram.html.

Decatur, Stephen. *Private Affairs of George Washington from the Records and Accounts of Tobias Lear.* Boston: Riverside Press for Houghton Mifflin, 1933.

DeWan, George. "The Island Washington Saw." *Newsday,* April 16, 1990.

Eide, Elizabeth. *Copiague: Your Town and Mine.* Copiague, NY: Copiague Public Schools, 1971.

Ellis, Edward Robb. *The Epic of New York City: A Narrative History.* New York: Old Town Books, 1990.

Federal Hall: National Memorial, New York City. National Park Service, U.S. Department of the Interior. Washington, D.C.: Government Printing Office, 1995.

Flexner, James Thomas. *George Washington and the New Nation, 1783–1793.* Boston: LIttle, Brown, and Company, 1970.

Flushing Meeting Religious Society of Friends. "Historic Meetinghouse: Flushing Quaker Meeting House." http://flushingfriends.org/history/40-2.

Founders Online. "George Washington." April 20, 1790. https://founders.archives.gov/documents/Washington/01-06-02-0001-0004-0020.

Friends of Historic New Utrecht, Brooklyn, New York. "History." http://www.historic.newutrecht.org/History.html.

Friends of Raynham Hall. "Raynham Hall Museum: A Crossroad of Long Island's Revolutionary Past."

George Washington's Mount Vernon. "First in War, First in Peace, and First in the Hearts of His Countrymen." http://www.mountvernon.org/digital-encyclopedia/article/first-in-war-first-in-peace-and-first-in-the-hearts-of-his-countrymen.

———. "George Washington the Farmer." The Digital Encyclopedia of George Washington. http://www.mountvernon.org/george-washington/farming.

———. "Surveying." http://www.mountvernon.org/digital-encyclopedia/article/surveying.

———. "Surveying Career." http://www.mountvernon.org/george-washington/washington's-youth/surveying.

———. "Ten Facts About the Grist Mill." http://www.mountvernon.org/the-estate-gardens/gristmill/ten-facts-about-the-gristmill.

George Washington's New York: How England's Treasured Colony Became the Capital of a New Nation. "George Washington's Presidency." National Parks of New York Harbor Conservancy, National Park Service.

George Washington's Professional Surveys. https://founders.archives.gov/documents/Washington/02-01-02-0004#document_page.

Gerry, Peggy N., and Roger G. Gerry. Old Roslyn. Roslyn, NY: Bryant Library, 1953.

Gish, Noel J. Smithtown, New York, 1660–1929. Virginia Beach, VA: Donning Company Publishers, 1996.

Goler, Robert I. Captial City: New York After the Revolution. New York: Fraunces Tavern Museum, 1987.

Gould, Zell Morris, and Henrietta M. Kleber. Colonial Huntington, 1653–1800. New York: Huntington Press, 1953.

Grasso, Joanne, Dr. The American Revolution on Long Island. Charleston, SC: The History Press, 2016.

———. Docent interview, Newburgh Headquarters, October 16, 2016.

Halsey, Carolyn. The Indians of Long Island. St. Petersburg, FL: Thomas-Maguire Printing Company, 1951, reprinted 1982.

Hattem, Michael D. "Newburgh Conspiracy." George Washington's Mount Vernon. http://www.mountvernon.org/digital-encyclopedia/article/Newburgh-Conspiracy.

———. "New York." George Washington's Mount Vernon. http://www.mountvernon.org/digital-encyclopedia/article/New-York.

Haworth, Paul Leland. *George Washington: Farmer: Being an Account of His Home Life and Agricultural Activities.* Indianapolis, IN: Bobbs-Merrill Company, 1915. https://archive.org/details/gerogewashington00hawawouft.

Hazelton, Henry Isham. *The Boroughts of Brooklyn and Queens Counties of Nassau and Suffolk: Long Island, New York, 1609–1924.* Vol. 1. New York: Lewis Historical Publishing Company Inc., 1925.

"Hempstead Town at a Glance." Town of Hempstead. Record Series, 1976. Hempstead Public Library.

Hemstreet, Charles. *When Old New York Was Young.* New York: Charles Scribner's Sons, 1902.

Hibbard, Shirley G. *Rock Hall: A Narrative History.* Mineola, NY: Dover Publications, 1997.

Historic Northampton Museum and Education Center. "Shays' Rebellion." http://www.historic-northampton.org/highlights/shays.html.

History of Queens County, New York, with Illustrations, Portraits, and Sketches of Prominent Families and Individuals. New York: W.W. Munsell and Company, n.d. https://archive.org/details/historyofqueensC00unse.

Horsley, Carter B. "Ecologists Join Politicians in an Effort to Save Great South Bay." *New York Times*, April 25, 1971.

Hughes, Robert C., Town Historian, comp. "A Brief Guide: The Arsenal, Huntington L.I., New York." Town of Huntington Town Board, n.d.

Huntington Historical Society. "A Historical Guide to Huntington."

———. "The 1750 David Conklin Farmhouse Museum." http://huntingtonhistoricalsociety.org/Visit/facilities/conklin-museum.

Irving, Washington. *Life of George Washington.* New York: G.P. Putnam, 1860. https://archive.org/details/lifeofgeorgewash01irvi.

Johnston, Henry Phelps, ed. *Memoir of Colonel Benjamin Tallmadge.* New York: Gilliss Press, 1904. https://archive.org/details/memoirofColonelb027409mbp.

Kolchin, Peter. *American Slavery, 1619–1877.* New York: Hill and Wang, 1993.

Lathrop, Elise. *Early American Inns and Taverns.* New York: Tudor Publishing Company, 1936.

Little, Shelby. *George Washington.* New York: Minton, Balch & Company, 1929.

Long Island Genealogy. "History of Coram: Focal Point of Brookhaven Town from 1785 to 1885." http://www.longislandgenealogy.com/community.html#coram.

Long Island's Tercentenary, 1936. New York: Long Island Association. https://archive.org/details/longislandsterce00dars.

Long Island Stories. "The Harts Tavern Mystery." https://sites.google.com/site/longislandstories/the-harts-tavern-mystery.

Lossing, Benson J. *The Diary of George Washington from 1789–1791: Embracing the Opening of the First Congress and His Tours through New England, Long Island, and the Southern States Together with His Journal of a Tour to the Ohio in 1753.* Richmond, VA: Press of the Historical Society, 1861. https://archive.org/details/diarygeorgewash001lossgoog.

———. *Harper's Encyclopedia of United States History: From 458 AD to 1909.* New York: Harper and Brothers, 1905.

———. "Results of the American Revolution." *Our Country: A Household History for All Readers.* 1877. http://www.publicbookshelf.com/public_html/Our_Country_vol_2/resultsof_bej.html.

Magnani, Edward. "Captain Daniel Youngs and His Order Book: Long During the Occupation, 1780–1783." *Nassau County Historical Society Journal* (1997).

Marshall, Bernice. *Colonial Hempstead: Long Island Life Under the Dutch and English.* 2nd ed. Port Washington, NY: Ira J. Friedman, 1962.

Maryland State Archives. "The Mount Vernon Compact of the Annapolis Convention." http://msa.maryland.gov/msa/mdstatehouse/html/compact_convention.html.

Mastromarino, Mark. "Biography of George Washington: Surveying the Land: An Early Career for Young Washington." Washington Papers, University of Virginia. http://gwpapers.Virginia.edu/history/articles/biography-of-george-washington.

McAtamney, Hugh. *Cradle Days of New York (1609–1825).* New York: Drew & Lewis, 1909.

Metcalf, Reginald, Jr. *A Brief History of the Arsenal.* N.p., 1978.

Miller, Bob. "Old First Presbyterian Church of Huntington, NY: History." Information narrative for Pastor Search Committee, 2003.

Moger, Roy W. *Roslyn Then and Now.* Roslyn, NY: Board of Education, 1965.

Moore, Rev. William H., DD. *History of St. George's Church, Long Island, NY.* New York: E.P. Dutton, 1881.

Morris, Richard, ed. *Encyclopedia of American History.* New York: Harper & Brothers Publishers, 1953.

Morse, John T., Jr. *American Statesmen*. Boston: Houghton Mifflin and Company, 1883.

The Mount Vernon Compact 2: Compact Between Virginia and Maryland, March 28, 1785. http://www.consource.org/document/the-mount-vernon-compact-2-compact-between-virginia-and-maryland-1784-3-28.

National Park Service, Department of the Interior. "The Battle of Long Island." Manhattan Sites, Federal Hall National Memorial.

Naylor, Natalie. *Journeys on Old Long Island: Traveler' Accounts, Contemporary Descriptions, and Residents' Reminiscences, 1744–1893*. Interlaken, NY: Empire State Books, 2002.

Newsday. "George Washington Slept Here: And Yankee Doodle Went to Halesite, Hempstead, and All Over Long Island." July 1, 1994.

New York City Parks. "Rufus King Park." https://www.nycgovparks.org/parks/rufus-king-park.

New York Yearly Meeting. "History of Manhasset Meeting." http://www.NYYM.org/Manhasset/history.html.

"Old Huntington Green Incorporated: A History of Preservation." Town of Huntington, Historian's Office, Main Street, Huntington.

Ostrander, Stephen M. *A History of the City of Brooklyn and Kings County*. Vol. 2. Brooklyn, NY: published by subscription, 1894. https://archive.org/details/historyofcityofbo20striala.

The Oyster Bay Historical Society, comp. *A Walking Tour of Oyster Bay: Town of Oyster Bay, Queens Co.* Mattituck, NY: Peconic Companies, 1996.

Patchogue Advance. "Old Resident Recalls Memories of Poetess and House on Hill." October 28, 1930. nyshistoricnewspapers.org/lccnSN8607/739/1930-10-28/ed-1/seq-9 (and seq-10).

Patchogue: A Brief History. Patchogue-Medford Library, n.d. history.pmlib.org/sites/default/files/Patchogue%020History%20Brochure.pdf.

Pearse, Joysetta Marsh, and Julius O. Pearse. "Index of Persons of Color: South Hempstead, NY 1790 to 1810." Freeport, NY: African-Atlantic Genealogical Society, n.d.

Pelletreau, William. *A History of Long Island: From Its Earliest Settlement to the Present Time*. Vol. 2. New York: Lewis Publishing Company, 1903. https://archive.org/stream/CU31924070695709#page/466/mode/2up.

Prime, Nathaniel S. *A History of Long Island: From Its First Settlement by Europeans to the Year 1845*. New York: Robert Carter, 1845. https://archive.org/details/ahistorylongis100primgoog.

Queens Jewels: A History of Queens Parks. City of New York Parks & Recreation, 2002.

Ramsay, David, MD. *The Life of George Washington, Commander in Chief of the Armies of the United States in the War Which Established Their Independence, and First President of the United States*. London: Luke Hanford & Sons, n.d. https://archive.org/details/lifeofgeorgewashi00mdgoog.

Riker, James, Jr. *The Annals of Newtown in Queens*. New York: D. Fanshaw, 1852.

Rines, Edward F. *Old Historic Churches of America: The Romantic History and Their Traditions*. New York: Macmillan Company, 1936.

Roe Tavern. http://www.3villagecsd.k12.NY.US/Elementary/minnesaue/3villagehist/RoeTavern.htm.

Rosenthal, Herbert. "Retracing Washington's Long Island Journey." *New York Times*, April 13, 1958.

Roslyn Landmark Society. Paper Mill. 2016 House Tour No. 7, June 4, 2016.
———. Van Nostrand–Starkins House. 2016 House Tour No. 9, June 4, 2016.

Ross, Peter. *A History of Long Island: From Its Earliest Settlement to the Present Time*. Vol. 1. New York: Lewis Publishing Company, 1903.

Rothstein, Edward. "A Founder's at Home." *New York Times*, September 15, 2011. http://www.nytimes.com/2011/09/16/arts/design/alexander-hamiltons-renovated-grange-review.html.

Ruff, Joshua. "Beacons for All: A History of Long Island Lighthouses." *Long Island Historical Journal* 2, no. 2 (Spring 1999).

Sagtikos Manor: The Oldest House in the Town of Islip. Sagtikos Manor Historical Society & Suffolk County Parks Department, n.d.

Sands-Willet House. http://www.cowneck.org/sands-willet-house/sands-willet-house.html.

Sayville Historical Society. "A History of Early Sayville." 1974.

Scott, Kenneth, and Susan E. Klaffky. *A History of the Joseph Lloyd Manor House*. Setauket, NY: Society for the Preservation of Long Island Antiquities, 1976.

Sincock, J. Morgan. *America's Early Taverns*. Lebanon, PA: Applied Art Publishers, 1992.

Smith, J. Lawrence. *The History of Smithtown*. Smithtown, NY: Smithtown Historical Society, 1961.

Smithtown News. "The Smithtown Washington Saw 200 Years Ago April 23, 1790." 1990.

Smits, Edward J. "Creating a New County: Nassau." *Long Island Historical Journal* 2, no. 2 (1999).
———. "Creation of Nassau County." *Long Island History Journal* 2, no. 2 (1990), 4.

Smucker, Philip G. "Washington on the Dance Floor." George Washington's Mount Vernon. www.mountvernon.org/george-washington/the-man-the-myth/athleticism/on-the-dance-floor.

Spaulding, E. Wilder. *New York in the Critical Period, 1783–1789.* New York: Columbia Univeristy Press, 1932.

Special Collections at Hofstra University. "250 Years in Suffolk: Invisible Ink and Black Petticoat Signals Used in Communication with General Washington." Verticle file, n.d.

Stevens, William Oliver. *Discovering Long Island.* New York: Dodd, Mead & Company, 1939.

Stiles, Henry R. *A History of the City of Brooklyn, Including Old Town and Village of Brooklyn, the Town of Bushwick, and the Village and City of Williamsburgh.* Vol. 1. Brooklyn, NY: published by subscription, 1867.

"St. John's Episcopal Church: Oakdale, Long Island." Information booklet published by the church.

Strong, Thomas M. *The History of the Town of Flatbush in Kings County, Long Island.* New York: Thomas A. Merceinm Jr., 1842. https:/archive.org/details/historyoftownoff01stro.

Stryker-Rodda, Kenn. "George Washington and Long Island." *Journal of Long Island History* 1 (1961).

Tallmadge, Benjamin. *Memoir of Col. Benjamin Tallmadge: Prepared by Himself, at the Request of His Children.* New York: Thomas Holman, 1858. https://archive.org/details/memoirofcolbenja00tall.

This Is Great Neck. Great Neck, NY: League of Women Voters, 1975.

Thomas Jefferson Monticello. "Northern Tour of 1791." Thomas Jefferson Encyclopedia. https://www.monticello.org/site/research-and-collections/northern-tour-1791.

Thompson, Benjamin F. *History of Long Island: From Its Discovery and Settlement to the Present Time.* Vol. 3. New York: Robert H. Dodd, 1918. https://archive.org/details/historyoflongisland/03thom.

Thompson, Mary. "Birthnight Balls." Compiled by Mount Vernon, the Fred W. Smith National Library for the Study of George Washington.

———. "George Washington and Taverns." Compiled by Mount Vernon, the Fred W. Smith National Library for the Study of George Washington.

Town of Hempstead Landmarks Preservation Commission. March 2001.

Town of Islip, George Washington Committee. "Town of Islip Celebration of the 200th Anniversary of President George Washington's Tour, Saturday April 21, 1990."

Trinity Church, Wall Street. "History." https://www.trinitywallstreet.org/about/history.

————. "History of St. Paul's Chapel." https://trinitywallstreet.org/about/stpaulschapel/history.

————. "St. Paul's Chapel." https://www.trinitywallstreet.org/about/st.paul'schapel.

Ullman, Albert. *A Landmark History of New York: Also the Origin of Street Names and a Bibliography.* N.p.: D. Appleton and Company, 1901. https://archive.org/details/alandmarkhistor02ulmagoog.

Waller, Henry D. *History of the Town of Flushing.* Flushing, NY: J.H. Ridenour, 1899. https://archive.org/details/historyoftownoff00wall.

Washington, George. *The Agricultural Papers of George Washington, 1732–1799.* Edited by Walter Edwin Brooke. Boston: Richard G. Badger, Gorham Press, 1919. https://archive.org/details/agriculturalpaper01wash.

Washington's Headquarters State Historic Site. "The Newburgh Address: March 10-15."

Washington's Inaugural Address of 1789. https://www.archives.gov/exhibits/american_originals/inaugtxt.html.

Washington's State Historic Site. The Newburg Address, March 10–15, 1783.

Weeks, George L. *Isle of Shells (Long Island).* New York: Buys Bros Inc., 1965.

West, H. Rosetta Terry, and Mrs. George N. Yetta Overton. "Old Indian Trails on Long Island." *Long-Islander*, April 17, 1925. https://nyshistoricnewspapers.org/lccn/sn83031119/1925-04-17/ed-1/seq-9.

Wilson, Edw. A. *Long Island's Story.* Garden City, NY: Doubleday, Doran & Company, 1929.

INDEX

ABOUT THE AUTHOR

Dr. Joanne Grasso is an Adjunct Associate Professor of History and Political Science specializing as an "Americanist" in the areas of the American Revolution, the American presidency and the founding documents, as well as Long Island history. She holds an interdisciplinary Doctor of Arts degree in Modern World History, two Master of Arts degrees in History and Government and Politics and a Bachelor of Arts degree in Politics, Economics and Society. Dr. Grasso is a member of the Society for Historians of the Early American Republic (SHEAR), Society for History in the Federal Government (SHFG), Daughters of the American Revolution (DAR), and the American Revolution Round Table (ARRT) in New York City. Her past career was in the travel industry, and she has traveled extensively both internationally and throughout the United States, particularly to historic sites.

Dr. Grasso is a native Long Islander. Her first book, *The American Revolution on Long Island*, published in August 2016, was followed by fifteen book talks on Long Island and in New York City. She is also working on conference papers and a third book on American Revolutionary women.

Visit us at
www.historypress.com